IMAGES of America
CHICAGO ITALIANS AT WORK

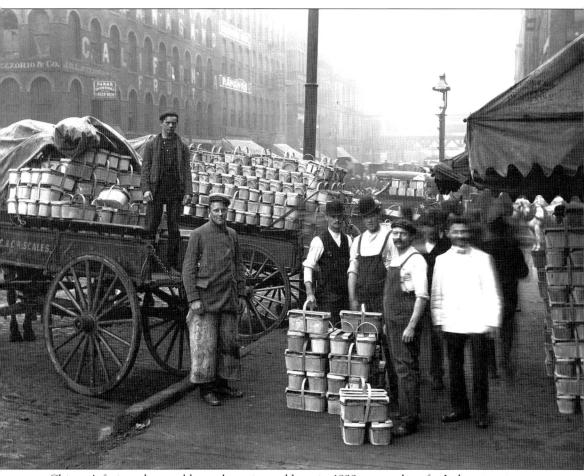

Chicago's fruit and vegetable market, pictured here in 1899, was a place for Italian immigrants to find jobs or build a family enterprise. In the background is the J. H. Lavezzorio Company, a food distributor at 114 South Water Street. (Courtesy of the Chicago History Museum, DN-0000137.)

On the cover: The Gonnella Baking Company was created in 1886 from a small kitchen in Chicago's Little Italy. Shown here are workers and neighbors posing for a photograph on Sangamon Street. Despite pedestrian traffic and street clamor, the horses and woman in the window are remarkably still. Today the Gonnella Baking Company is alive and well in Chicago. (Courtesy of the University of Illinois, Chicago Library, IAC 237.LA and the Marcucci family.)

IMAGES of America
CHICAGO ITALIANS AT WORK

Peter N. Pero

ARCADIA
PUBLISHING

Copyright © 2009 by Peter N. Pero
ISBN 978-0-7385-6187-5

Published by Arcadia Publishing
Charleston SC, Chicago IL, Portsmouth NH, San Francisco CA

Printed in the United States of America

Library of Congress Catalog Card Number: 2008927345

For all general information contact Arcadia Publishing at:
Telephone 843-853-2070
Fax 843-853-0044
E-mail sales@arcadiapublishing.com
For customer service and orders:
Toll-Free 1-888-313-2665

Visit us on the Internet at www.arcadiapublishing.com

To my grandfather Nicholas Pero: farmworker, bartender, and milk delivery driver. He nurtured my parents and gave us his labor and love.

Contents

Acknowledgments 6

Introduction 7

1. Migration, Street Work, and Survival 9
2. Coal, Cartage, and Construction 23
3. Skilled Artisans and Their Trades 37
4. A Heritage of Family Enterprise 49
5. Workshops, Sweatshops, and Industry 65
6. Radical Movements 77
7. Trade Unionism 93
8. Labor and Politics 113

Bibliography 127

Acknowledgments

I must acknowledge the contributions of many people who assisted with this book. It began in 2007 by meeting Melissa Basilone and John Pearson at the Arcadia Publishing office. They believed in my dream and made it happen.

I am forever grateful to Dr. Byung-In Seo who gave personal and technical advice through the many months of this project. Her moral support and attention to detail saved the day.

I believe Dr. Dominic Candeloro is the "Dean of Italian Studies in the Midwest." Many precious photographs and oral records are archived in the library of the Italian Cultural Center in Stone Park, Illinois. Dr. Candeloro generously shared this collection.

My thanks to the Chicago History Museum's Robert Medina and Erin Tikovitsch. The Immigration History Research Center at the University of Minnesota helped me locate some rare materials on Italian Americans thanks to Daniel Necas.

The Special Collections Division in the Daley Library at the University of Illinois at Chicago (UIC) offered many fine photographs on Italian Americans. On my photograph credits in this book, "IAC" signifies this collection. I am particularly grateful to Valerie Harris, Janis Taiwo, and Peggy Glowacki at UIC.

At the Chicago Public Library, Lorna Donley and Glen Humphreys were helpful. Likewise the Illinois Labor History Society supplied this book with a number of powerful pictures, and I salute Les and Linn Orear for promoting the cause of labor history over many decades. Joe Costigan at the UNITE HERE union offered many photographs and much enthusiasm for my project.

My graphic arts consultant, Cathy L. Smith, made technical adjustments night and day on this project. Her judgment always kept things in focus for me. Comp-Ed II also provided vital resources for the book.

The Palazzolo family donated artwork for this book; their pictures keep the memory of Maxwell Street alive. Lori Grove and Laura Kamedulski, who I have worked with for several years at the Maxwell Street Foundation, gave advice based on their Arcadia Publishing experience.

There were many Italian Americans who contributed their personal photographs. Ann Marie Tricoci-Quercia opened up her dining room and her family scrapbook for this project. A special thanks to Roy Pedi, Louise DiSabato, Jeff Caracci, Tania Pilli, Tom Marcucci, Josephine and Vince Tenuto, the Davino family, Bill Davy, and Rene Turano for their donations.

INTRODUCTION

Much has been written about Italians in America with regard to sports, crime, food, and entertainment. Far less has been written about their work. An economic imperative carried most Italians to America in the first place. This imperative is the basis for my book.

Italians arrived in the United States without capital or social connections. They did not bring elaborate resumes, Mapquest, or a marketing plan. Nevertheless most Italians persisted in America and survived with a reasonable degree of success. Their strong backs, talents, and familial bonds helped pave the way to economic gain. Chicago benefited from their labor. In this book, I define labor as work for wages, a day's work for a day's pay.

The scope and sequence of this book is roughly limited to a period between 1890 to 1970. This was a time when industry was king in Chicago. I focus on the industrial sector because it provided a port of economic entry for first- and second-generation Italians. Later generations developed careers in fields too numerous to include in this publication.

Where I mention business in this book, it is in the context of family operations where the owner worked alongside the employees. Later some of these ma-and-pa businesses grew into much larger enterprises, but I include them because these families continue to operate their businesses nearly 100 years later.

This book lacks the space to chronicle Italians who worked in government and many white-collar professions. Also I apologize for not including thousands of Italians who worked in the arts and sciences. Given the space limitations of this Arcadia publication, I find it impossible to include all the trades and professions where Italians made their mark. I leave their stories for another writer.

For serious scholars in this field, I strongly suggest a visit to the Immigration History Research Center (IHRC) at the University of Minnesota. It was created in 1965 by Dr. Rudolph Vecoli, who pioneered new research directions on Italian Americans. He expanded the IHRC collection on numerous ethnic groups in the Midwest.

My own interest in the field of Italian studies began as a young graduate student at the University of Illinois at Chicago in 1978. I joined in a grant to preserve the history of Italians in Chicago and was able to meet several trade union activists who are included in this book. Most of these characters have passed from the scene, but this book is a memoriam to their labor. Photographs from many of these union veterans are labeled "IALC" in courtesy of the Italian American Labor Council of Greater Chicago.

This Arcadia publication begins with the subject of migration and survival. The *paisani* found pick-and-shovel jobs or worked as peddlers and itinerant day laborers until they became

accustomed to the American labor market. Soon these Italians found higher-paying jobs in coal mines and on railroads in Illinois.

The brick-and-mortar trade was a popular entree to the urban workforce. Hod carriers, tunnel workers, and bricklayers found work in an expanding city. With all these jobs, the work was mainly outdoors and did not require much licensing, formal education, or discourse in the English language.

As immigrants moved "out of the cold and into the furnace," there were plenty of factories and sweatshops in industrial Chicago to provide work. Photographs in this book from Inland Steel, Pullman, Western Electric, Florsheim, International Harvester, Crane, U.S. Steel, and Hart Schaffner and Marx are evidence. Some of these companies still exist today; some have morphed into new corporations, but most have disappeared. Workers of Italian descent played a large role in the life of these enterprises.

Beyond large industrial firms, there were smaller foundries, offices, kitchens, storefronts, and workshops in Chicago that provided jobs for many Italians. In the area of self-employment, Italians carved a niche in such trades as barbering, tailoring, music, and food services. This book provides ample photographic evidence of their experiences.

I do not suggest that Italian Americans followed a direct path from rags to riches in America. Unsafe working conditions, long hours, and low wages were typical during the first 50 years of the Italian experience in Chicago. The work was humbling, but they were not humbled.

In researching this book, I often found evidence of Italian participation in trade unions, strikes, and political movements. Italian unionists, socialists, and even anarchists did not always agree on a political agenda, but they did agree on the right of working men and women to an improved quality of life.

I am indebted to many photographers, amateur and professional, living and dead, who captured history through the camera lens. More than 15 sources made donations. From the roughly 200 photographs in this book, I hope my readers see a pattern of work and enterprise that is common to all immigrants in America. Their story is your story.

One

Migration, Street Work, and Survival

From 1890 to the present, millions of Italians migrated to the United States in search of better living conditions. In Italy, a lack of jobs, scarcity of land, disease, political persecution, military conscription, and even earthquakes were factors that pushed the Italians to look for new homes in North and South America.

In 1904, a boat ticket from Naples to New York City cost the equivalent of about three months' wages in Calabria and even more for immigrants from Sicilia. Added to this was the cost for a train ticket from New York City to Chicago. Without high-level skills or social connections, many newcomers relied on an Italian labor broker, called a *padrone*, who located jobs for a finder's fee. No government welfare or employment service existed to help the newcomers secure bread and work.

The Near West Side of Chicago came to be called Via Veneto or Little Italy. By the 1920s, the 19th Ward held more than 15,000 Italian residents. Other *colonia* grew in proximity to areas of employment. Italians who resided in Chicago Heights were in close range to steel mills, workers in Pullman lived in the shadow of the rail yards, and Italians in "Little Sicily" on Chicago's North Side were within walking distance to many factories and family enterprises.

Many Italian immigrants of a century ago, especially from agricultural areas, had skills that did not easily transfer to an American industrial metropolis. Some Italians, like the silk workers from Piedmont or stonemasons from Carrara, did bring valuable skills with them, but their lack of English and working capital prevented many artisans from maximizing their crafts.

Without a formal education or industrial skills, the Italian newcomers relied on their strong backs and manual dexterity to find work. They found jobs hauling freight, pick-and-shovel work, street vending, and in factories and sweatshops in the industrial core of Chicago. The next two chapters of this book document the earliest forms of labor that Italians inherited.

Faced with joblessness, political upheaval, and even earthquakes, many thousands of Italians migrated to America and to Chicago in particular. Pictured here in their native Calabria are Pietro Ambrosio and his wife, Maria Crivara. (Courtesy of the Tricoci/Quercia family.)

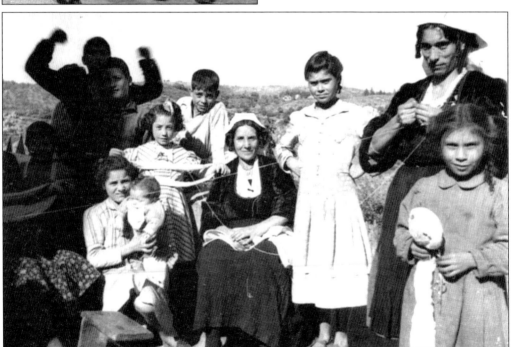

Families were the building blocks of society in Italy. In this photograph, women and children from the town of San Giovanni In Fiore pose for the camera. The women look stolid and forthright; the children seem playful and not camera shy. (Courtesy of the Tricoci/Quercia family.)

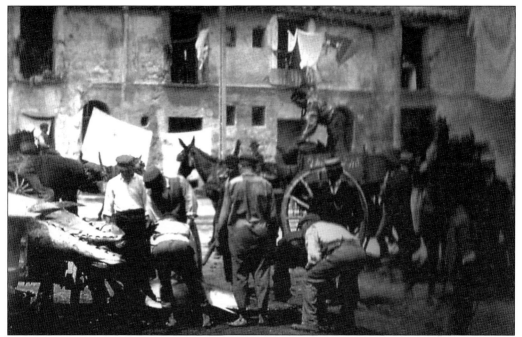
Italian immigrants from the Mezzogiorno, or southern region of Italy, relied on agricultural work. In this photograph, *paesani* from a small village bring their produce to market. (Courtesy of Giornale Di Sicilia.)

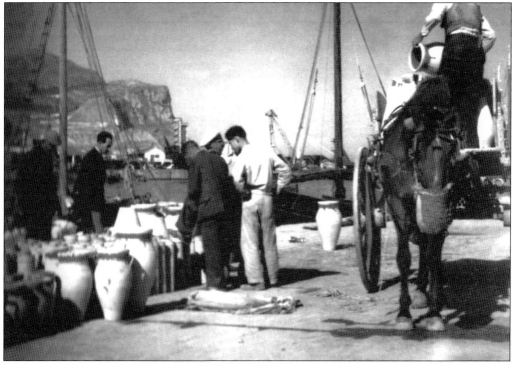
For centuries, Italians earned a living through fishing, shipping, and the sea trade. Here at dockside, merchants buy and sell ceramics. (Courtesy of Giornale Di Sicilia.)

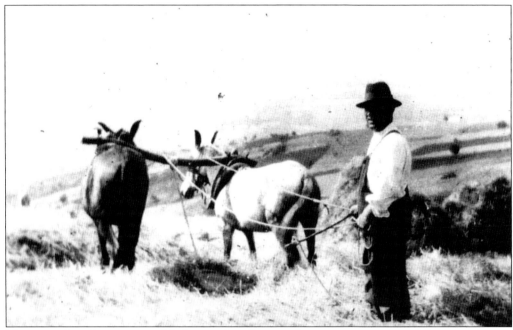

The agricultural economy of Italy was based on a sharecropping system. The *contadini*, or peasant-farmers, gave a portion of their crop profits as rent to a wealthy landowner. Little hope existed for the contadini to buy farmland in Italy; even the weather sometimes conspired against them. (Courtesy of Casa Italia.)

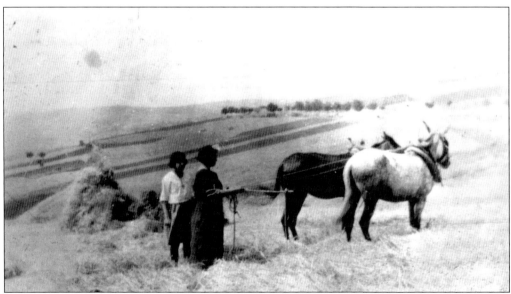

Farmland in Italy was often controlled by wealthy families who passed ownership of the property to their family members. This feudal system operated for hundreds of years in Italy. In this 1923 photograph, Angeline DeBoris hitches her plow in the province of Potenza. (Courtesy of the UIC library, IAC 136.33.)

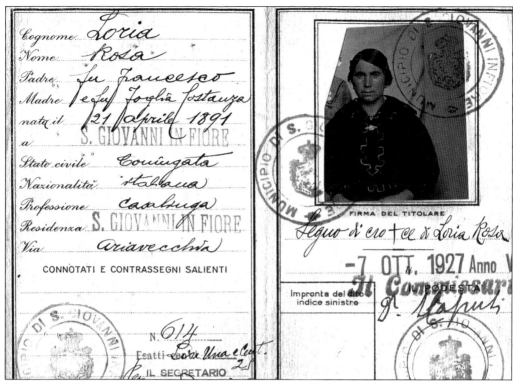

Migration to America was a practical solution for millions of Italians in jeopardy. In this photograph is Rosa Loria, who was born in 1891 and migrated to America as an adult. The passport, dated in 1927, is a poignant historical document. (Courtesy of the Tricoci/Quercia family.)

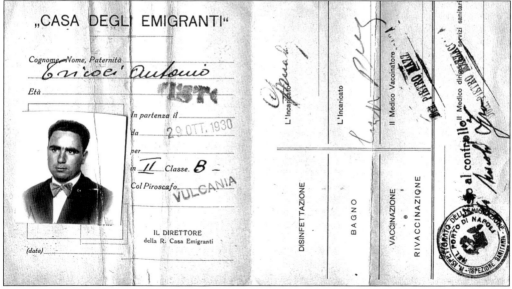

Arriving in America in 1930, Antonio Tricoci found work as a chef at several Chicago restaurants. The Italian passport in this photograph notes that Antonio has been "bathed, disinfected, vaccinated and re-vaccinated" in order to pass through the immigration process. (Courtesy of the Tricoci/Quercia family.)

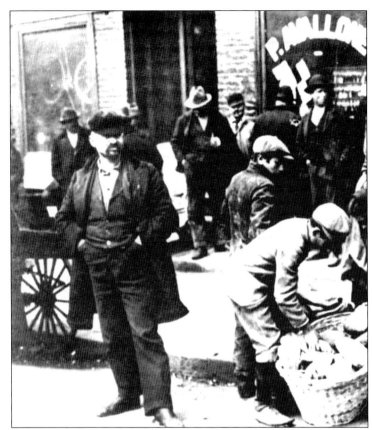

The padrone was an agent for Italians on both sides of the Atlantic Ocean. He arranged sea passage, changed money, brokered jobs, located housing, and even translated for Italian immigrants, all for a fee or *bossatura*. From the vantage point of contemporary times, the padrone seems like a parasitic figure, but at the beginning of the 20th century, governments offered little assistance to immigrants. The padrone filled the void. (Courtesy of the Library of Congress.)

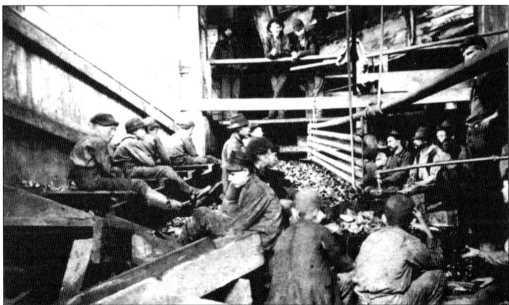

Italian children joined in the army of immigrant kids who found plenty of work in the streets of Chicago. Jobs sorting nuts, assembling paper flowers, embroidering garments, or rolling cigarettes are a few examples of handwork for agile fingers. (Courtesy of the Library of Congress.)

This newspaper peddler, Dominic DiLeonardis, peddles his wares on Dearborn Street in Chicago. His job was secure, and his clientele was assured. Historian Dominic Candeloro discovered that "men with origins in the town of Ricigliano in Italy had a virtual monopoly on news-vending jobs throughout the Loop by the 1940's." (Courtesy of Dominic Candeloro.)

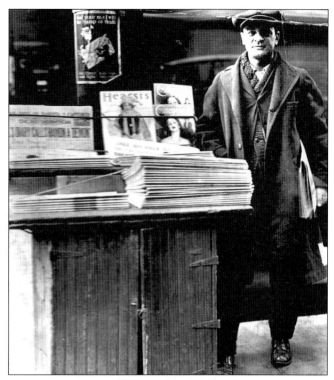

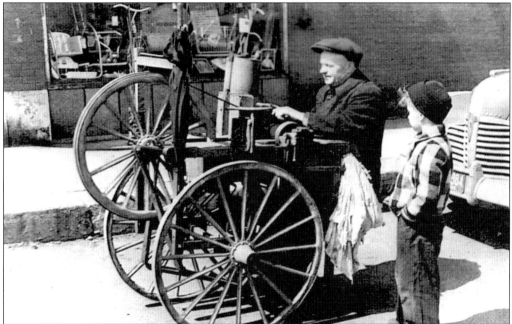

Street peddling was a fast track to employment for immigrants. Joseph Antonucci was a knife sharpener who pushed his cart in Chicago and Hammond, Indiana. Antonucci earned the most cash on Thanksgiving Day when many families needed a sharp carving knife. In 1958, Joseph died; his handmade cart was donated by his daughter Louise to the Chicago Historical Museum. (Courtesy of Louise Disabato.)

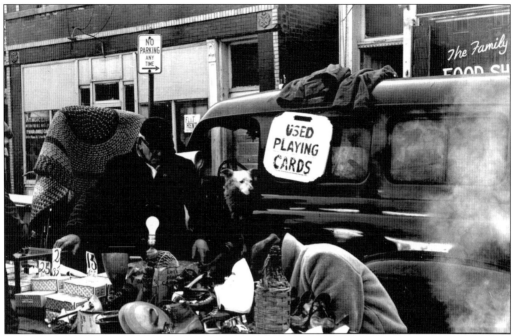

From 1912 to 2002, Maxwell Street was a mecca for immigrants who wished to trade and sell goods. In the early 20th century, big State Street department stores did not cater to immigrant customers. The Maxwell market, however, was more accessible and colorful and offered more bargains for seemingly everything on earth. (Photograph by Marcia Palazzolo.)

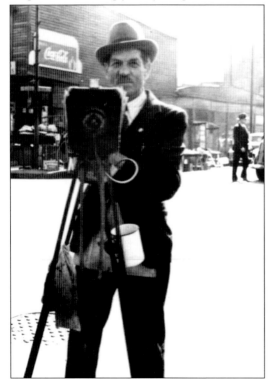

Joseph Carsello was a popular vendor on Maxwell Street. In this 1939 photograph, he tries his luck as a street photographer. He also sold balloons and played an accordion on the street. (Courtesy of Casa Italia.)

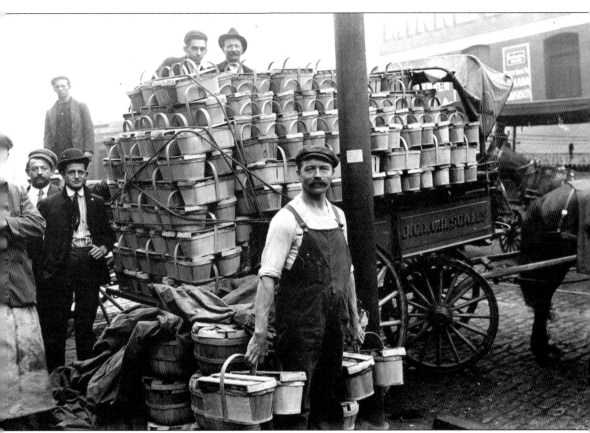

The fruit and vegetable trade in Chicago was a door to full employment for Italian immigrants. This crew loads peaches for the Scales Company at the South Water Street Market. (Courtesy of the Chicago History Museum, DN-0000137.)

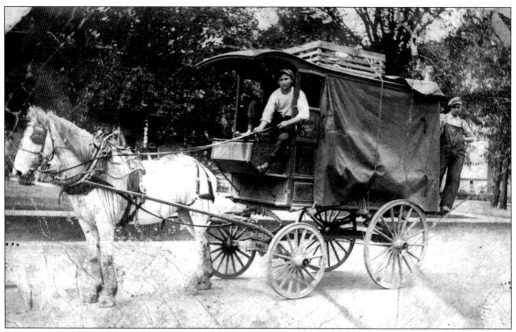
Antonio Calderone, shown here in 1919, created a family produce business in Forest Park, approximately 10 miles west of downtown Chicago. (Courtesy of the Tricoci/Quercia family.)

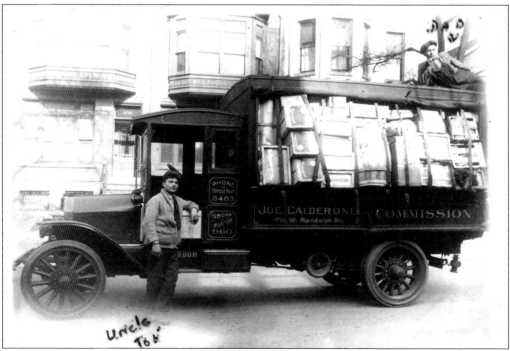
Here Antonio rests atop the produce truck while his brother Joseph stands at the cab. Today Anthony Calderone, the grandson of Antonio, is the mayor of Forest Park. (Courtesy of the Tricoci/Quercia family.)

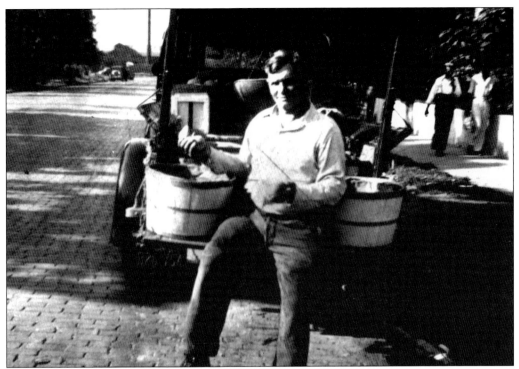

This photograph, taken in the 1930s, shows Charles Zarante peddling fruit from the tailgate of his truck in Chicago. (Courtesy of Casa Italia.)

Peter Pero Sr. began to work in the fruit and vegetable business at the age of 10. He delivered produce by wagon to railroad stations. By 1908, his Sicilian family established their own brand of vegetables. (Courtesy of the Pero family.)

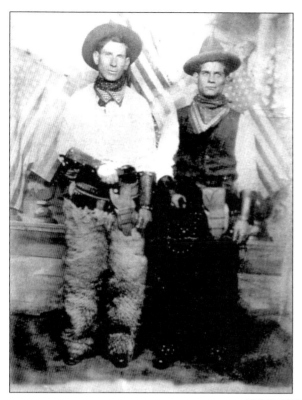

Here are some Italian cowboys. These two immigrants, from Cefalu in Sicily, migrated west in order to find work on the railroad in 1910. Many Chicago Italians found the work and weather agreeable in the western states and stayed on. (Courtesy of Roy Pedi.)

Filippo Pedi (left) and his cousin Vince hold hands in Montana, as was the custom in Sicily. After working several years on this railroad track gang, Filippo returned to Chicago to open a grocery store in 1919. (Courtesy of Roy Pedi.)

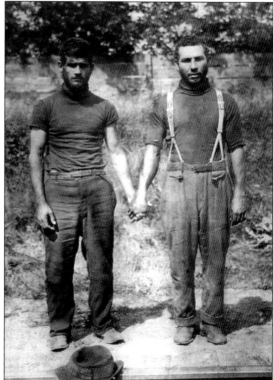

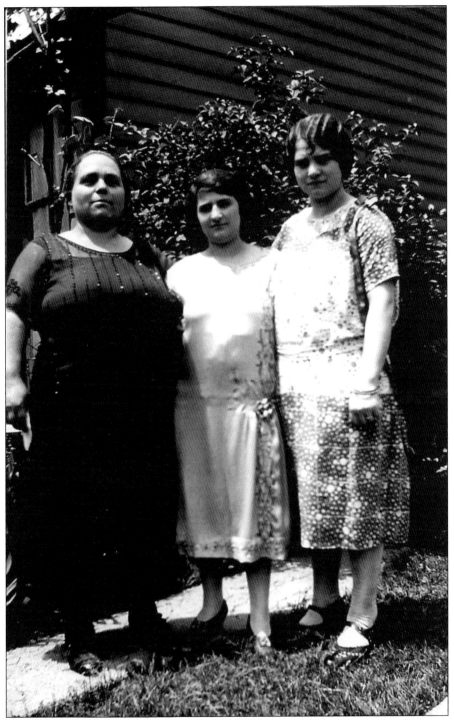
This family takes a break in the backyard. From left to right are Mary Carriere and her daughters Agostina and Vincenza in 1925. Families often shared what they earned with relatives at home and in Italy. Some families sent nearly 75 percent of their wages back to Italy. (Courtesy of Jacqueline M. Pero.)

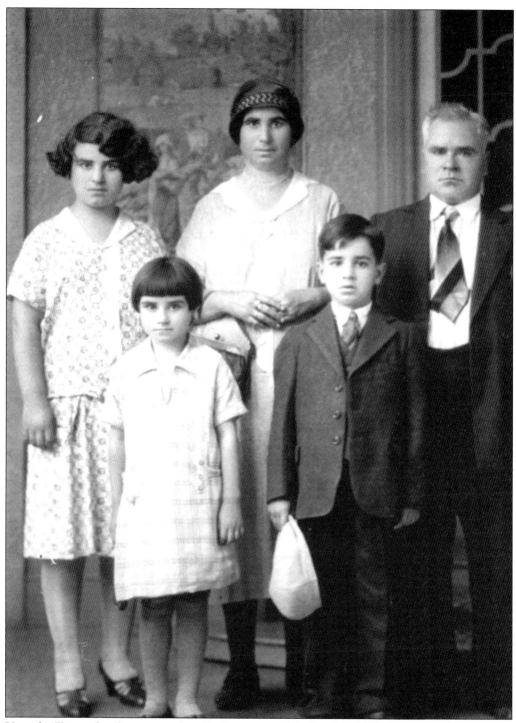
Here the Tricoci family poses in their Bridgeport neighborhood in 1927. Giovanni, the patriarch (far right), emigrated from Italy in 1909. This poignant portrait gives indications of family strength and prosperity. (Courtesy of the Tricoci/Quercia family.)

Two

COAL, CARTAGE, AND CONSTRUCTION

At the beginning of the 20th century, Illinois was one of the largest coal-producing states in America. Mining required thousands of manual laborers, and immigrants responded. The work required a strong back, the inclination to work underground for long hours, and a bit of courage. Furthermore, English language skills were not a prerequisite. In the early 1900s, workers received about $2.50 for a 12-hour day in the coal mines.

For Northern Italians who once dug tunnels through the Alps Mountains, coal mining was quite similar. They found work in Illinois coal towns such as Cherry, Braidwood, Coal City, Cherry, Benton, West Frankfort, Herrin, and Carbondale. Today, although mining has dwindled in Illinois, many coal towns such as Torino are Italian enclaves.

As the second-largest city in America around 1900, Chicago offered plenty of work in the construction industry. From skyscrapers to bungalows, Italians participated in all tasks from pouring foundations to capping off cupolas. To enter the building trades meant starting from the bottom as a hod carrier. This meant carrying bricks, digging ditches, or burrowing tunnels. Later Italians grew to master many of the building trades, and the children of the immigrants rose to become heads of several construction unions.

Cartage of all kinds offered experienced drivers a job. Dairy products, baked goods, beer, meat, ice, and more needed same-day delivery in an era before home refrigeration and chemical preservatives were common.

The railroads were another source of work for the Italians. Chicago was a hub for cross-country rail lines. Furthermore, the city boasted the most extensive streetcar system in America by 1930. At this time, the largest ethnic group employed in track maintenance was the Italians. They laid track or repaired rails in the heat of summer and ice of winter. This chapter describes new paths to gainful employment for Italian immigrants.

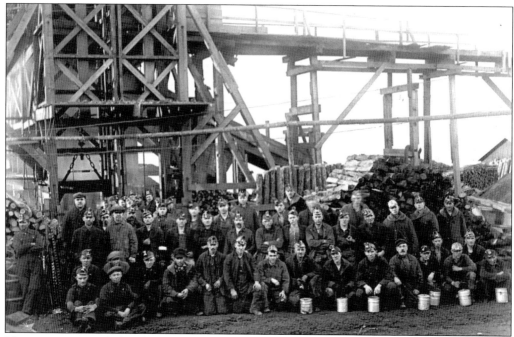

Mining was a quick but brutal route to an income for an immigrant. From an oral history collection in Stone Park, one Italian commented, "My grandfather was killed in their coal mines . . . the worker was like a cheap piece of equipment to be replaced." Pictured here are Enrico Bertoletti and fellow miners from downstate Illinois. (Courtesy of Casa Italia.)

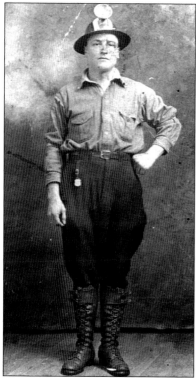

Italian miners found work in Illinois towns like Braidwood, Toluca, Torino, Coal City, Benton, West Frankfort, and Herrin. In this 1914 portrait, Oreste Pacucci stands ready wearing his miner's gear. (Courtesy of Casa Italia.)

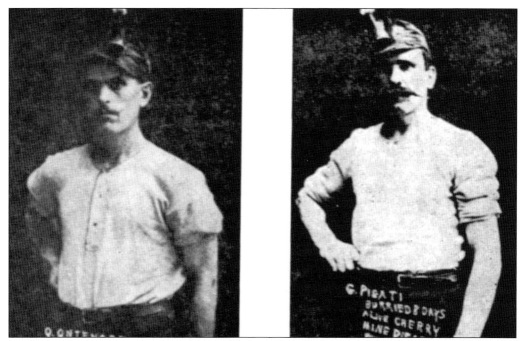

In 1909, a disastrous cave-in occurred in Cherry. A fire in the mine burned the wooden escape ladders. One fourth of the miners were Italian. Two victims are pictured here. (Courtesy of the Immigration History Research Center, University of Minnesota, 000920.)

After eight days in the Cherry mines, 20 miners managed to survive, yet 259 died of burns or suffocation. Here are two more Italians who perished. As a result of this disaster, the State of Illinois created a workers' compensation program and mine-safety legislation. (Courtesy of the Immigration History Research Center, University of Minnesota, 000921.)

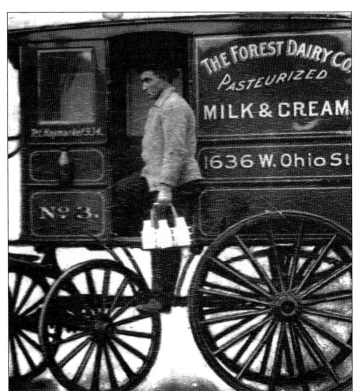

Cartage of all types moved goods through Chicago, particularly before the days of home refrigeration. Meat, baked goods, ice, and dairy products were popular items for door-to-door delivery. Pictured here is Joe DiChristofano en route in 1910. (Courtesy of Casa Italia.)

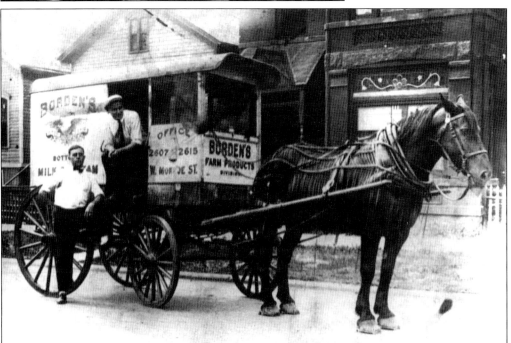

Joseph Bordenaco's delivery route for the Borden Dairy Company "covered the Great Lakes"; he serviced Huron, Erie, and Superior Streets on Chicago's Near North Side. Milk drivers were unionized, and by 1922, about 50,000 delivery workers were members. (Courtesy of Casa Italia.)

In this 1912 photograph, Gennaro Bruno rides a cart on the Grand Trunk Railway line. Chicago was a central hub for national rail carriers like the Illinois Central, New York Central, Rock Island, Milwaukee Road, Santa Fe and other lines that converged in the city. (Courtesy of Dominic Candeloro.)

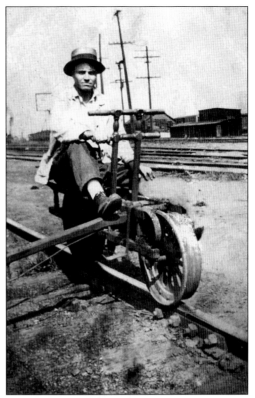

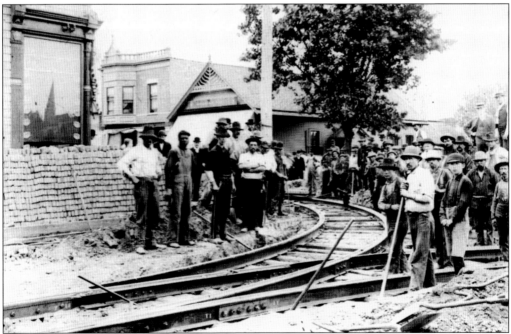

In this photograph, workers are repairing car lines on the South Side of Chicago. The union for municipal track maintenance was comprised of nearly all Italians, and most was from Sicily, Naples, or Calabria. (Courtesy of Casa Italia.)

The Pullman Corporation manufactured railroad cars in its historic plant at 111th and Champlain Streets. It was also the location of a huge national strike in 1894, which pitted federal soldiers against railroad workers. (Photograph by Peter N. Pero.)

Pictured here is Guiseppe Ostarello at the Pullman Corporation factory in 1945. Constructing the elaborate dining cars and sleeping coaches was complex work similar to building a cruise ship or an aircraft. (Courtesy of Casa Italia.)

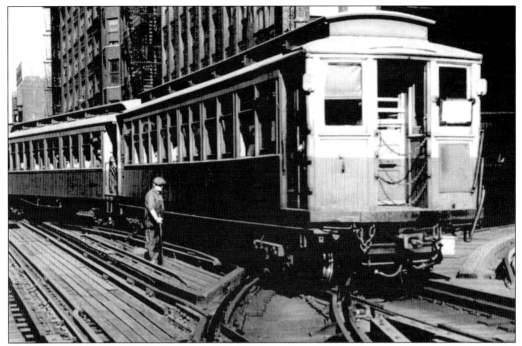

By the 1920s, Chicago offered one of the largest municipal rail systems in America. Most of the elevated lines required Chicago Transit Authority (CTA) observers to monitor speed and traffic from towers and track platforms. (Courtesy of the Chicago Transit Authority.)

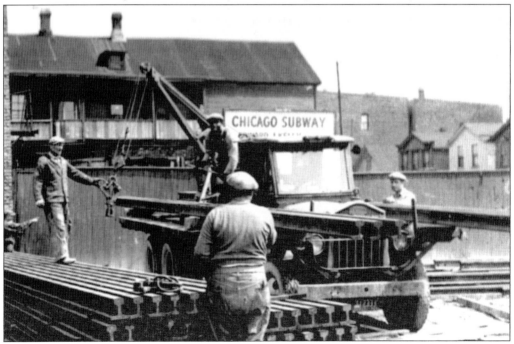

In 1942, Chicago constructed a subway line. This subterranean line had strategic military value and provided more rapid transit for travelers. In addition, the new subway provided plenty of construction jobs. (Courtesy of the Chicago Transit Authority.)

This is to Certify that

Mario Tricoci

Age 26 years was duly admitted as a member of the

AMALGAMATED ASSOCIATION OF STREET, ELECTRIC RAILWAY and MOTOR COACH EMPLOYES OF AMERICA

Workers for municipal trains and buses were organized into a union as early as 1892. CTA workers were affiliated with their local union as well as the American Federation of Labor, an international union organization. (Courtesy of the Tricoci/Quercia family.)

Mario Tricoci was born in the province of Cosenza, Calabria, in 1919. In Chicago, he worked in the "cleaning pit" of the CTA. Tricoci retired after 37 years with the CTA. His father also worked for the CTA. (Courtesy of the Tricoci/Quercia family.)

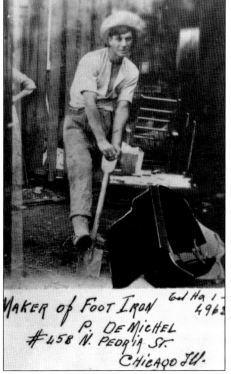

A strong back and shovel were all some immigrants needed to qualify for a construction job in Chicago. The portrait of this Italian laborer from Peoria Street is telling. Frank Bertucci, who recalled these times for an oral history project, tells this story: "My partner took a chisel and cut three inches off his shovel." He explained to me, "They cut my wages today so I'll cut the size of their shovel.'" (Courtesy of the UIC library, IAC 227.1.)

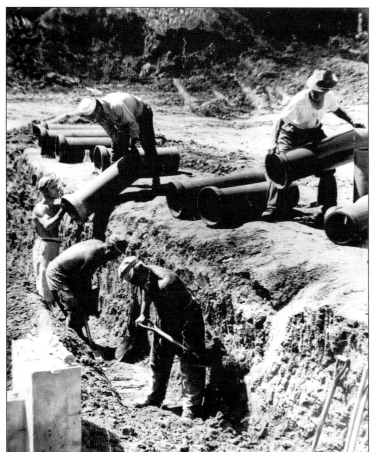

Chicago is a city of canals, locks, and a huge sanitation complex. So many sewer workers existed that they formed their own independent union. Here Angelo Salvitti, from Abruzzo, Italy, labors with his crew in Chicago. (Courtesy of the Tricoci/Quercia family.)

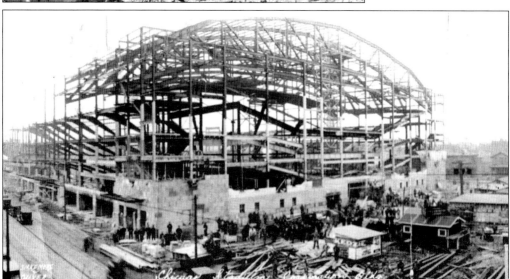

One of many big public projects providing work to immigrant laborers was the Chicago Stadium, under construction here in 1928. The building was an enormous venue for hockey, basketball, trade shows, rock bands, and opera. (Courtesy of Vincent Occhipinti and Casa Italia.)

Immigrants who were fortunate enough to enter the construction trades found entry level positions carrying brick or breaking stone. Shown here is the membership card for Ludovico Candeloro in 1941. This Hod Carriers' and Building Laborers' Local Union No. 5 later grew into the much larger Laborers' International Union. (Courtesy of Dominic Candeloro.)

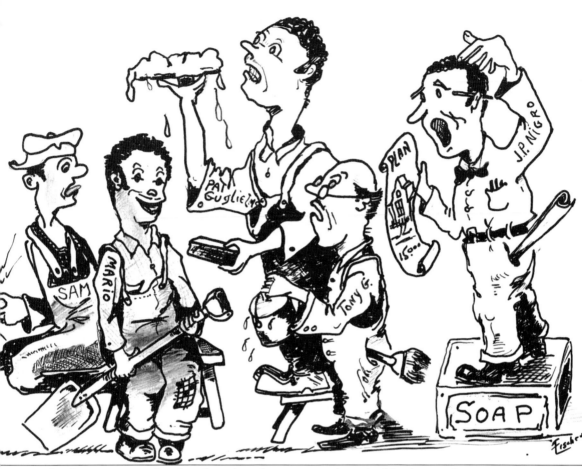

In this caricature, five friends and tradesmen struggle to build a home. One is a carpenter, another is a tile worker, and another is a cabinetmaker. All four workers are being supervised by Mario Tricoci in 1960. (Courtesy of the Tricoci/Quercia family.)

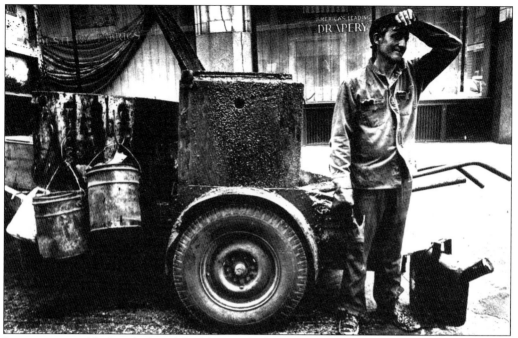
Immigrants could often find work building and rebuilding the young, brash city of Chicago. One Italian oral history subject reported, "The first day I worked—God, I was only seventeen years old. By dinner time I could not even open my hands." Pictured here is Mike Russo shoveling tar. (Courtesy of Casa Italia.)

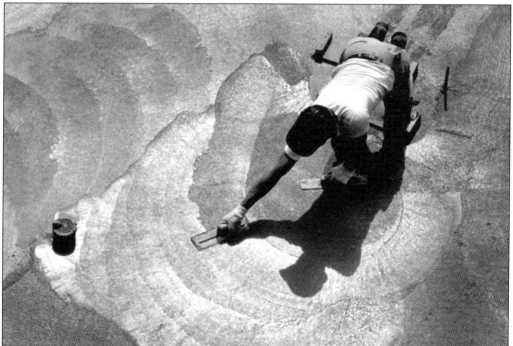
Cement and masonry workers were needed to construct the downtown city skyline. This worker is trawling fresh cement. (Courtesy of the Chicago History Museum, i51569, M. J. Schmidt.)

This photograph, taken in 1962, shows the Marina Towers Apartments in mid-construction. The twin towers are constructed with daisy-shaped slabs of concrete suspended on a central stalk, which holds elevators and utility cables. The design was advanced for its time; unfortunately four construction workers lost their lives building the towers. (Courtesy of the Chicago History Museum, i51567.)

Three
SKILLED ARTISANS AND THEIR TRADES

Some Italian immigrants brought skills that a hungry city like Chicago needed. Stonemasons for example found plenty of work building the young, brash city. The artistry of young masons from Toscana, Lombardia, and Venezia was evident throughout the construction of the World's Columbian Exposition in 1893. Members of the Societa degli Stuccatori e Decoratori helped fashion Roman-style pavilions from stucco and horsehair. The "White City" was the beginning of a long tradition of stonework that continued in the Midwest for decades. As late as the 1970s in Chicago, most blueprints for laying terrazzo flooring were still printed in the Italian language.

Music was essential to the Italian community, as vital as their daily bread. Opera, jazz, dance music, and traditional tunes were part of the repertoire. Italian musicians played at weddings, banquets, churches, parties, and in the many clubs in Chicago's Loop. Commercial opportunities abounded but usually as part-time work.

Tailors and garment workers from Italy easily found work in the clothing industry. Women as well as men did the cutting, trimming, basting, buttonholing, and other garment work for large firms like Hart Schaffner and Marx Inc. or the Kuppenheimer Company. Italian workers in the tailoring trade were among the first to spearhead a huge trade union effort in Chicago by 1910.

Typically immigrant artisans at the beginning of the 20th century found themselves in a nonunion environment. Barbers, musicians, and shoe workers are a few examples. Later chapters in this book will explain how these trades evolved into higher-paying unionized work.

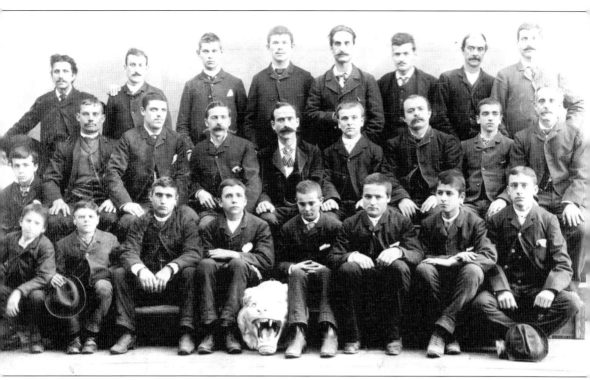

Established in 1886, the Daprato Statuary Company provided work to many Northern Italians from the provinces of Lombardy, Tuscany, and towns near stone quarries in Italy. (Courtesy of the Chicago Public Library, Special Collections ws1.3.)

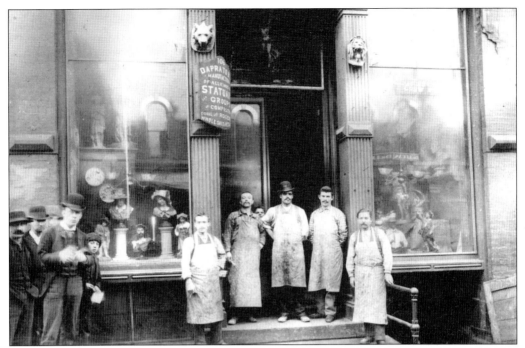

The Daprato Brothers Statuary Company was a large employer of Italian artisans in Chicago. Here craftsmen display everything from busts to cemetery stones in the Daprato storefront around 1900. (Courtesy of the Chicago Public Library, Special Collections ws1.3a.)

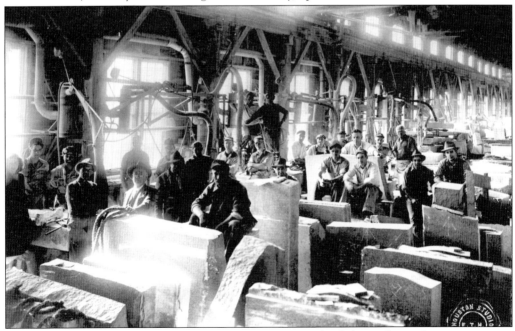

These masons cut and polished huge chunks of granite to be fashioned into decorative pieces. Many were members of the Societa degli Stuccatori e Decoratori Italiani in Chicago. In 1892, these artisans were erecting elaborate stucco pavilions for the city's World's Columbian Exposition or "White City" as it was called. (Courtesy of Casa Italia.)

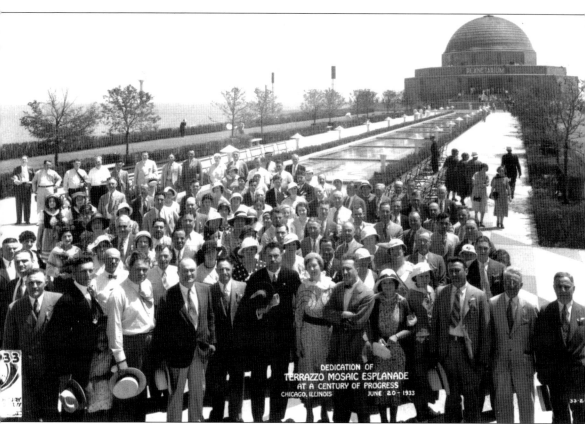
Terrazzo stonework is an art form as old as the Roman Empire. Giovanni D'Ambrosio carried the craft from Venice to Chicago in 1884. D'Ambrosio's enterprise later became the John Caretti Company and earned acclaim at Chicago's Century of Progress Fair in 1933. Here employees pose for the unveiling of the terrazzo esplanade at the fair's Chicago Planetarium. (Courtesy of the UIC library, IAC 174.28.)

The terrazzo process mixes marble chips with colored pigment and cement. This mix is bonded to a slab and often bordered with brass. In this Chicago co-op apartment building, John Caretti Company artisans tiled the floors, walls, and ceilings too. Up to the 1970s, terrazzo artisans in Chicago continued to label their blueprints in Italian. (Courtesy of the UIC Library, IAC 174.28.)

The John Caretti Company specialized in elaborate lobby tile and terrazzo as shown here in this art deco lobby at the Otis Elevator Company in Chicago. The building itself was designed by the noted architects Holabird and Root. Other notable lobby work from the John Caretti Company can be seen at the Chicago Tribune Tower, Michael Reese Hospital, and the Chicago Board of Trade Building. (Courtesy of the UIC Library, IAC 174.16.5.)

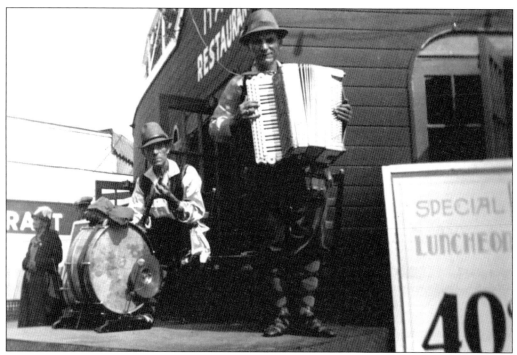

Musical skills, learned in Italy and carried to Chicago, helped many immigrants to earn a living. The accordion player in this photograph is Joseph Carsello. He played music indoors and out with his partner. (Courtesy of Casa Italia.)

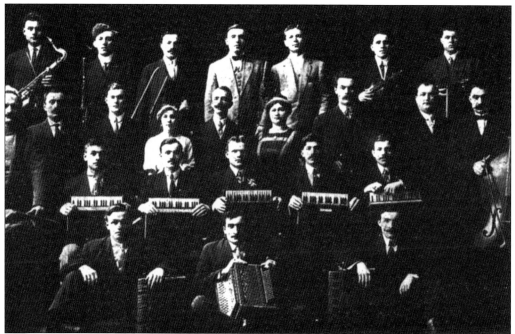

Italian families wanted music from the old country for weddings, church functions, and special occasions. Music was a part-time job for many immigrants who held full-time work elsewhere. Pictured here is the Bartoli Orchestra in 1910. (Courtesy of IALC.)

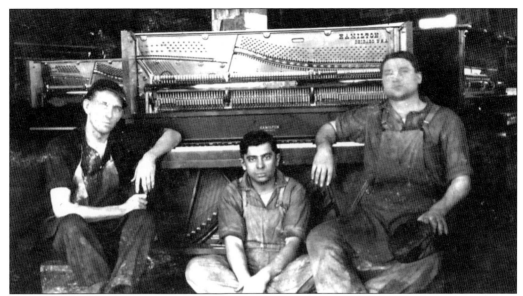

The Hamilton Piano Company hired skilled craftsmen who could fashion wood, ivory, and brass into a fine musical instrument. James Jacobucci (seen in the photograph above) sits between fellow workers at Hamilton Piano Company. (Courtesy of Casa Italia.)

In 1930, these immigrant artisans posed at the Hamilton Piano Company with woodworking tools in the foreground. (Courtesy of Casa Italia.)

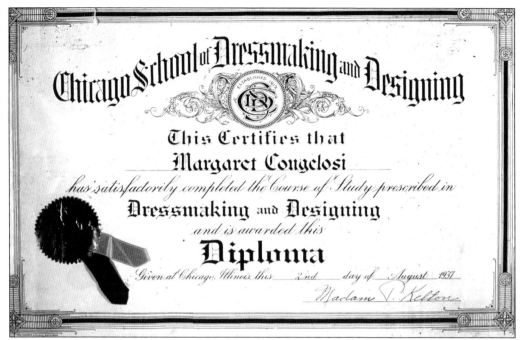

Italian tailors possessed many talents but not without schooling. This certificate, belonging to Margaret Congelosi, was awarded in 1937 for completing a dressmaking and design training course. (Courtesy of Casa Italia.)

Since the 1920s, the Kuppenheimer Corporation on Lake Street was a large employer of garment workers in Chicago. Also by 1920, this company was a labor stronghold as men and women united to make Kuppenheimer Corporation a union shop. Pictured here is Josephine Blecha at her machine. (Courtesy of UNITE HERE.)

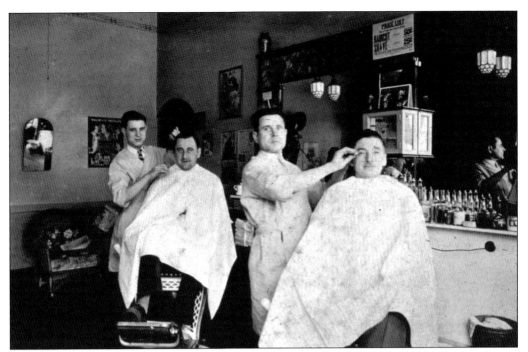

Silvio Petucci (rear) and his father set up this Chicago barbershop in the 1930s. At this shop, a haircut cost 50¢, and a shave was 25¢. (Courtesy of Casa Italia.)

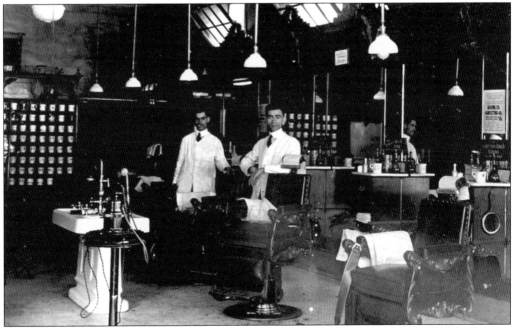

Sam Cosentino graduated from the Chicago Barber School in 1914. His first barbershop was at Taylor and Halsted Streets, and then he moved to Ashland and Van Buren Streets. Cosentino described the shop to the Chicago Oral History Project in 1978, "They had shaving mugs. Almost every customer had his own . . . with his name on it. The mug used to go from generation to generation." (Courtesy of Casa Italia.)

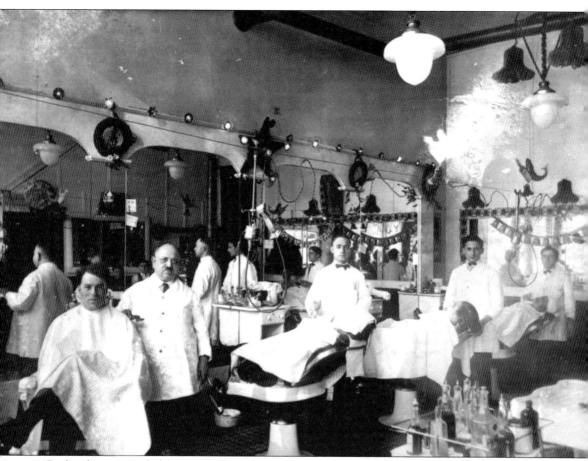

Barbershops provided haircuts, shoe shines, and plenty of social bonding in Chicago. Frank Cacucciolo's shop on the Near West Side is heavily decked out for Christmas in this 1922 photograph. (Courtesy of Casa Italia.)

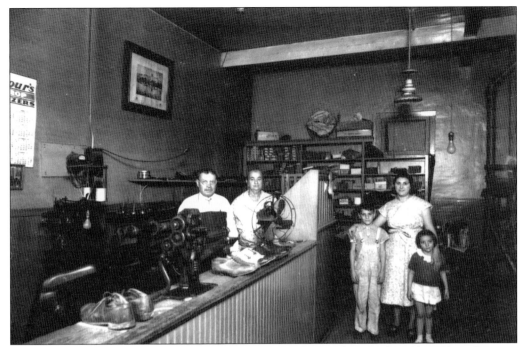

Another family operation in Chicago's Near West Side was the Venditti Shoe Shop. Lorenzo Venditti and his son Leonard ran this store at 169 East Twenty-third Street in 1942. (Courtesy of the UIC Library, IAC 177.1.)

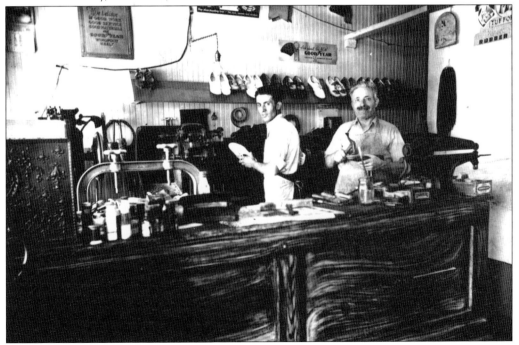

The shoe trade was a popular one for Italian immigrants. This father and son team established a cobbler shop in Mount Prospect during the 1930s. The son, Michael Moretti, stands behind his dad at a sewing machine. (Courtesy of the UIC Library, IAC 133.2.)

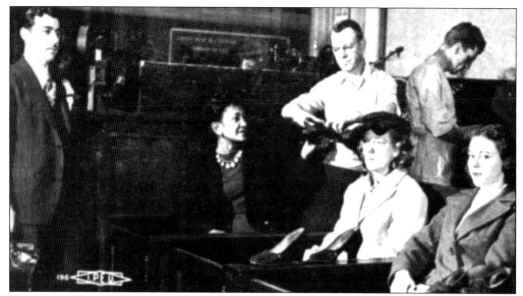

Many workers in the shoe industry hoped to build a union. Vito Losito (far left) helped recruit them. In this 1950s photograph, union activists give free shoe repairs for workers who walk the picket line. (Courtesy of IALC.)

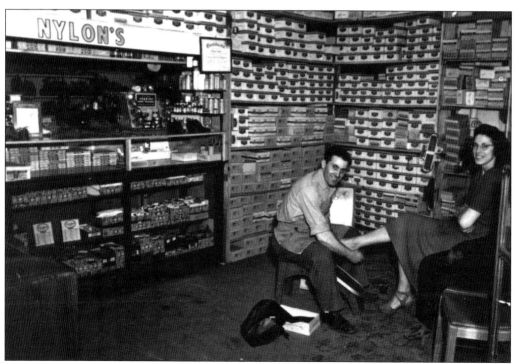

Mike Moretti moved from the shoe repair shop, where his dad started the trade, to a shoe sales store. This new store was located at 224 Green Bay Road in Highwood, a Chicago suburban enclave of Northshore Italians. In addition to shoes, this store sold nylon stockings and plenty of socks as well. (Courtesy of the UIC Library, IAC 133.7.)

Four

A Heritage of Family Enterprise

One way up the economic ladder in America was for families to pool their resources. Italian immigrants often shared housing with relatives and paesani. Another method was through mutual-aid societies that would pool their pennies to create a revolving loan program for members or a burial allowance for emergencies.

A small business was a popular road to self-sufficiency and success. Italian family members frequently banned together to form ma-and-pa operations that became profitable businesses. In Chicago, the Ferrara family created a sweetshop. The Davino family started a pizzeria, and the Lezza family launched a pastry business. These are examples of family enterprises with continuous growth for nearly 100 years. In addition, family members started these operations and continue to work side by side with employees and customers on a daily basis. This criterion was used in selecting the enterprises for this chapter.

Historian Dominic Candeloro reports that Italians in the food industry are still plentiful in Chicagoland. He discovered that in 1995, there were more than 1,000 restaurants, 64 bakeries, 88 catering and banquet halls, plus 116 family-run grocery stores. There are many more Italian businesses that have functioned in Chicago for decades yet still remain family owned and operated. Hardware stores, tailor shops, taverns, and hundreds of operations have grown from immigrant roots. The focus in this chapter is on food enterprises. They serve as examples for hundreds of businesses too numerous to include in this book.

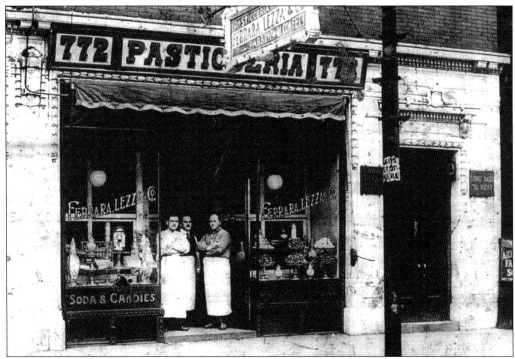
In 1908, Salvatore Ferrara and several of his family members opened a confectionery shop at 722 West Taylor Street in Little Italy. The store was crowded with "confetti" (candy-coated almonds), cookies, and candy. (Courtesy of the Ferrara family.)

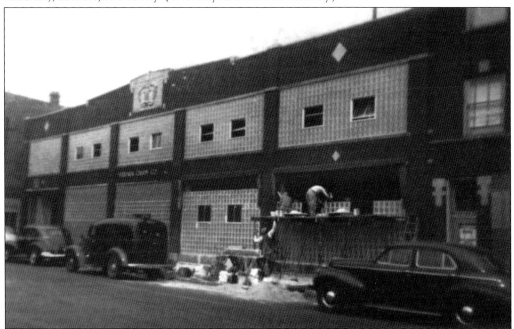
Operations were split in 1922 with candy manufacturing moving west of Ashland Street and retail confections still sold at the old stop. See chapter 5 for more information on large-scale candy production in Forest Park. (Courtesy of the Ferrara family.)

With the construction of the University of Illinois campus in 1963, the death of the old Ferrara pastry shop was assured. After demolition, the store moved to 2210 West Taylor Street pictured here. (Photograph by Byung-In Seo.)

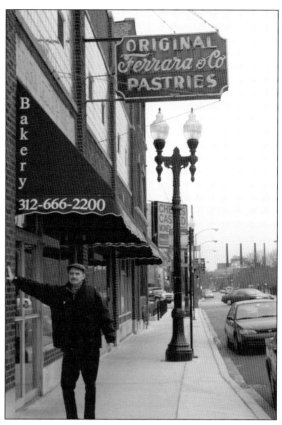

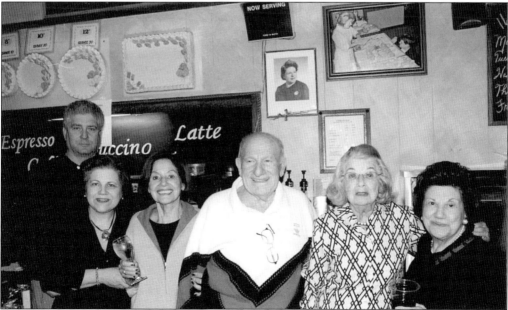

In 2008, the Ferrara family continues to run the store. After a century of operation, a luncheon menu, espresso bar, and Web site have been added to the little shop on Taylor Street. (Courtesy of the Ferrara family.)

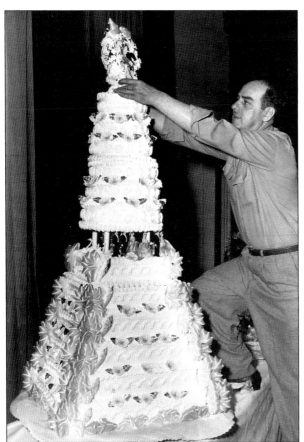

A cottage industry existed in Chicago around Italian weddings. Special cakes, flowers, dresses, tuxedos, and music were all required. Here a baker applies his sense of artistry and enterprise. (Courtesy of Dominic Candeloro.)

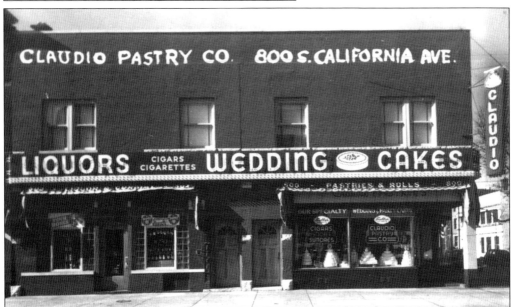

Italian wedding cakes from the Claudio Bakery at 800 South California Avenue were large and elaborate. (Courtesy of the UIC Library, IAC 226.1.)

In the 1920s, the bakery business was rough and tumble. Horse-and-wagon transportation was used by this driver to deliver door-to-door, rain or shine. Giovanni Pippan tried to shorten hours and increase pay. In 1933, he formed an Italian bread drivers' union organization. Pippan was subsequently killed in Cicero, Illinois. (Courtesy of the UIC Library IAC 59.3.)

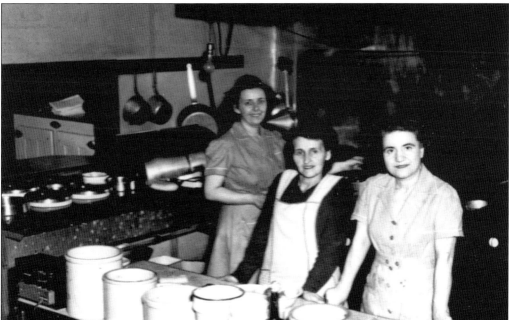

By the 1950s, the Italian community had expanded west with a large concentration in the area of Grand and Austin Avenues. Neighborhood merchants catered to Italian tastes. Here Amabile Santacaterina (left) helps the kitchen crew at the Belvedere Restaurant. (Courtesy of Dominic Candeloro.)

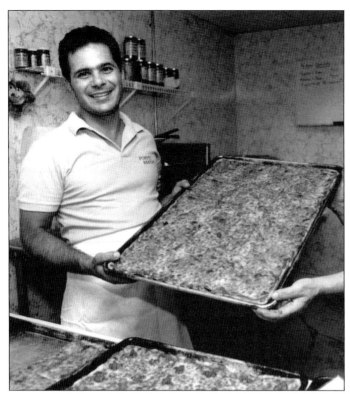

A longtime survivor in Little Italy is the Pompei Restaurant. It started in 1909 as a pizza bakery managed by Luigi Davino. Here Ralph Davino bakes fresh pizza for hungry customers. (Courtesy of the Davino family.)

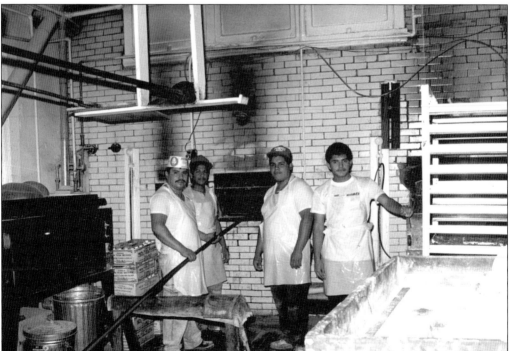

Pompei Restaurant continued to grow as each generation added new ingredients. Here four bakers raise new dough. (Courtesy of the Davino family.)

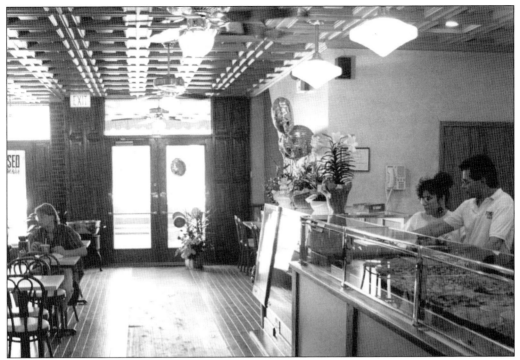
By the 1970s, Pompei grew from a stand-up bakery on Loomis Street to a sit-down cafe at 1455 West Taylor Street. The menu expanded. (Courtesy of the Davino family.)

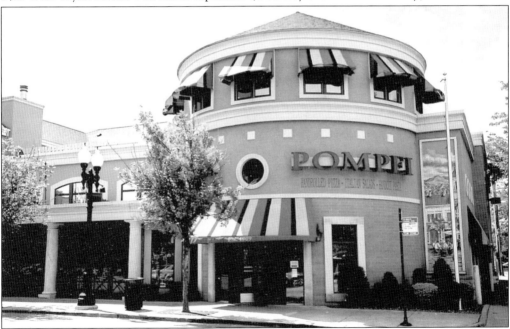
By 1999, Pompei exploded. Their full-size dining room, banquet room, and drive through facility covered half a block at 1531 West Taylor Street. In addition, three suburban outlets were established. Always the Davino family worked side by side with kitchen help, cooks, and customers to maintain quality and cuisine. (Courtesy of the Davino family.)

In 1922, Carmen Turano arrived from Calabria, Italy, looking for work as a baker. Later his brothers Mariano (pictured here) and Eugene arrived in Chicago with family. By 1966, the brothers teamed up to build a baking business. (Courtesy of the Turano family.)

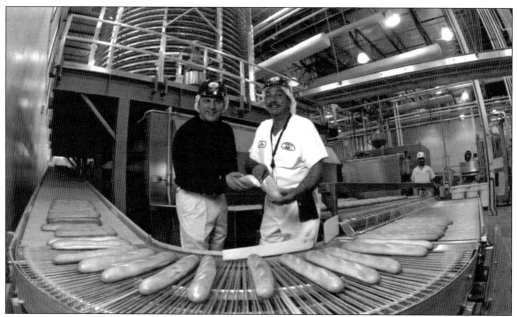

Turano products include hoagie rolls, ciabatta bread, pizza crust, French bread, panini loaves, and breadcrumbs. A third generation of the Turano family has developed sophisticated systems for distributing these bread products across the Midwest. (Courtesy of the Turano family.)

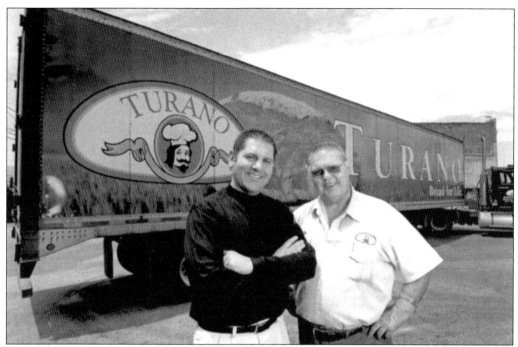

Mariano's sons built the business into a powerhouse operation. They established a plant of 30,000 square feet in Berwyn, where it stands today. In this photograph, Joe Turano and Mike Hopp discuss transport logistics. (Courtesy of the Turano family.)

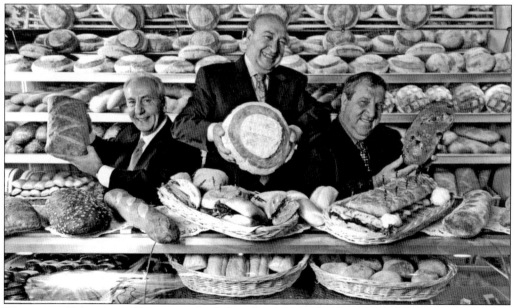

The sons of Mariano still manage the bakery business today but are deeply involved in other pursuits. Renato Turano (center) won a seat in the Italian Senate as representative of Italians living in North America. The other brothers, Anthony and Giancarlo, support social and cultural activities in Chicago's Italian American community. (Courtesy of the Turano family.)

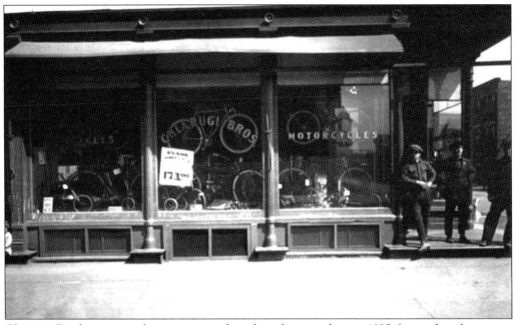
Chiarugi Brothers was a place to repair a bicycle or buy a gadget in 1925. It stood at the corner of Taylor and Aberdeen Streets. (Courtesy of Casa Italia.)

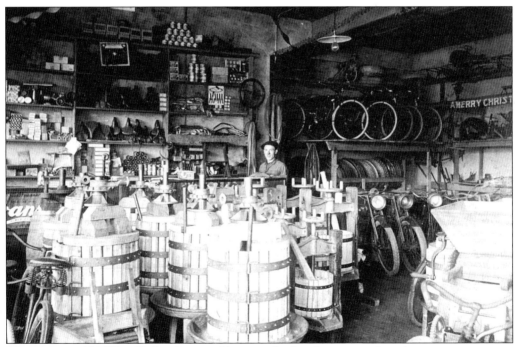
The store at 1022 West Taylor Street sold a varied of tools, toys, and trinkets to customers in Little Italy. Today the store stands one block west at 1449 West Taylor Street. (Courtesy of Dominic Candeloro.)

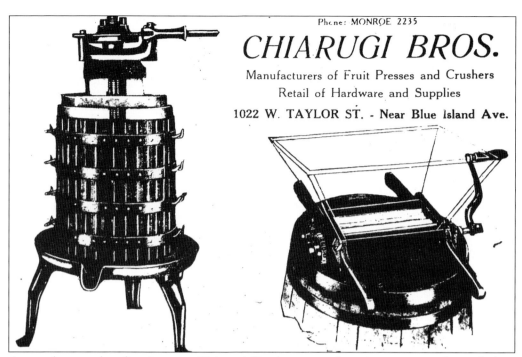

A popular merchandise item at Chiarugi Brothers was the wine press machine. Italian customers kept a hand in homemade wine making, especially during Prohibition times. (Courtesy of Casa Italia.)

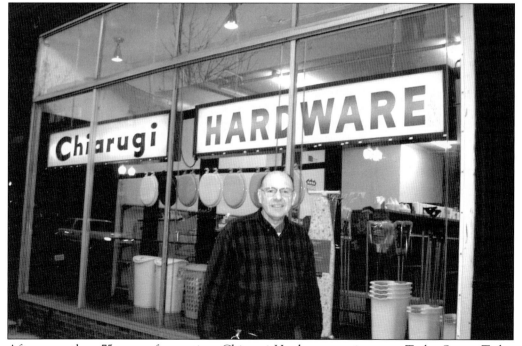

After more than 75 years of operation, Chiarugi Hardware continues on Taylor Street. Today Paul Rinaldi (pictured here) offers an array of hardware and still sells wine-making supplies at the store. (Photograph by Peter N. Pero.)

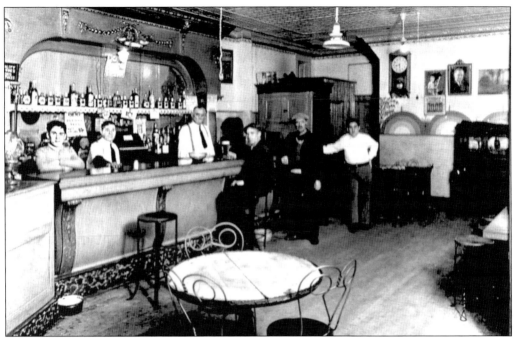

The tavern has long been a haven for conversation and libation in Chicago. It was also a convenient place for workingmen to cash a paycheck, as many banks did not offer services to blue-collar workers at the beginning of the 20th century. Shown here is the interior of Faso Tavern around 1935. (Courtesy of Casa Italia.)

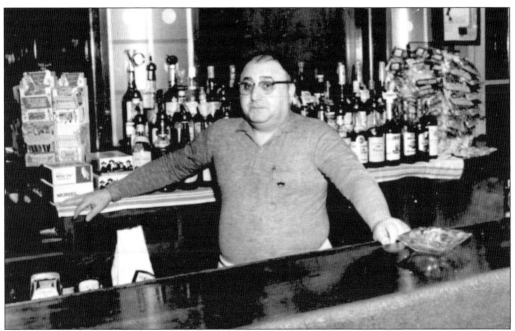

Nicholas Pero harvested vegetables, delivered milk, and drove a taxi. In 1950, he decided to look for an indoor job with more social contact. Pero joined his brothers in the bar business; he remained there for more than 20 years. (Courtesy of Jacqueline M. Pero.)

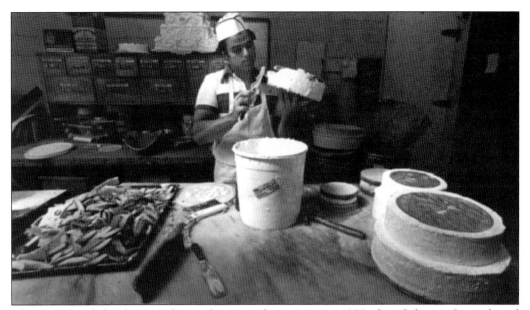

The Lezza family has been in the confectionery business since 1908 when Salvatore Lezza shared his plans for a sweetshop with Salvatore Ferrara. Lezza's shop was only a few blocks from the Jane Addams's Hull House and was displaced by the University of Illinois in the 1960s. (Courtesy of the Lezza family.)

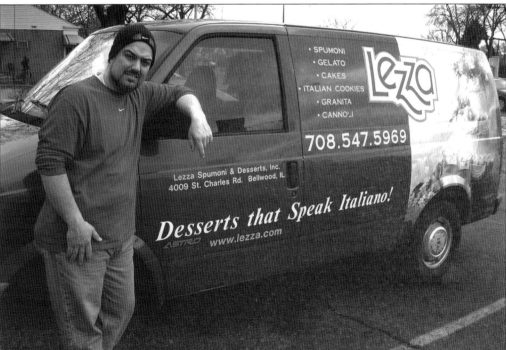

Today the Lezza store is located in suburban Bellwood. The menu still offers traditional Italian sweets like spumoni, cannolis, gelato, and elaborate wedding cakes. Not only does the Lezza company truck the desserts to suburban locations, the store mails them to customers as far away as Alaska. (Photograph by Peter N. Pero.)

The Victor Lezza Company prepares Italian treats rarely found in Chicago sweetshops. *Zeppole* is a cream pastry especially served on St. Joseph's Day, every year. Other Lezza specialties are *granita* (Italian-style sorbet) and their spumoni ice cream is made from a secret recipe imported by Salvatore Lezza from Naples in 1905. (Courtesy of the Lezza family.)

Pictured above are three generations of the Lezza family who give personal attention to food preparation, shipping, and customer contact. (Photograph by Peter N. Pero.)

Giuseppe Quercia came to Chicago from Cimitile, Italy, in 1968. As a teenager, his first job was at Freddy's Pizza in Cicero. After working in the kitchen for many years, Quercia bought the business and changed it from a typical pizzeria to a gourmet delight. Assisted by Ann Marie Tricoci-Quercia, Freddy's Pizza now sells fresh-cooked and packaged Italian foods to customers throughout Chicagoland. This photograph shows the Quercias (front) with a satisfied customer. (Courtesy of the Tricoci/Quercia family.)

The St. Joseph's Table has been an Italian tradition in Chicago for more than 100 years. In this photograph, patrons who are Italian, Croatian, Irish, African American, and Polish are at the table with a little help from Chicago mayor Richard J. Daley. (Courtesy of the Tenuto family.)

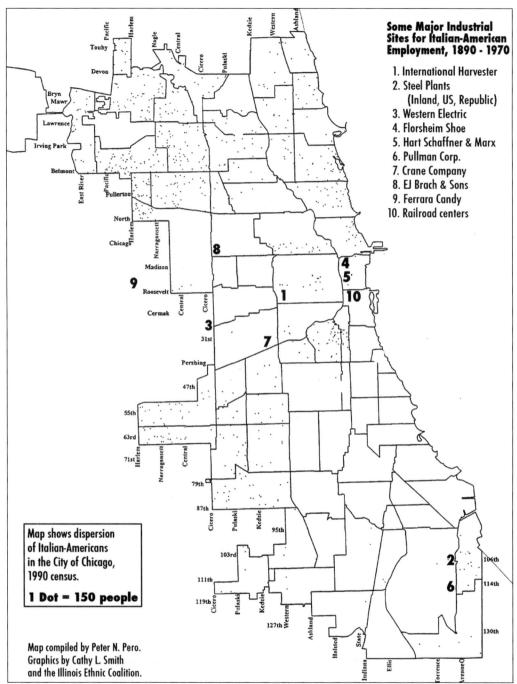

This map shows a collection of large industrial firms where many Italian Americans found employment from approximately 1890 to 1970. At that time, many of these jobs were either within walking distance or a brief streetcar ride from residential concentrations of Italians. However, the 1990 census data on this map indicate that many Italians have migrated away from the old industrial centers of employment in Chicago.

Five

Workshops, Sweatshops, and Industry

Chicago has long been a workshop to the world. Factories, foundries, and manufacturing plants attracted immigrants to the city for decades. Italians found work at some of the largest employers in the area: Pullman for railroad stock, Western Electric for phone equipment, Florsheim for shoes, and U.S. Steel for metals. One of the largest employers of Italian immigrants was International Harvester, a worldwide manufacturer of farm machinery. The plant located at Blue Island and Western Avenues was within walking distance for thousands of Italians in the Oakley Avenue neighborhood.

At the beginning of the 20th century, conditions in the industrial sector were sometimes brutal and unfair to immigrants. In the needle trades, if workers failed to meet production quotas, they were forced to take garment pieces home. In heavy industries like steel, accidents and personal injuries were common. Wages could not always match the cost of living in Chicago due to economic inflation, recession, and constant competition from immigrant newcomers.

Sweatshops and businesses that employed children caused alarm among social workers at Jane Addams's Hull House. Children on Chicago's West Side were paid on a piecework basis for embroidering, jewelry making, cigarette rolling, brush making, and street vending of all kinds. For thousands of minors, the idea of contributing money to the family household was often more important than attending school.

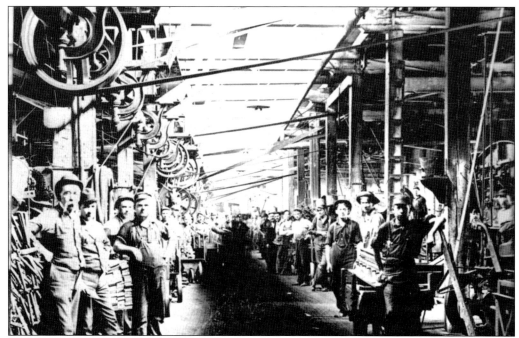

One of the largest factories on the West Side of Chicago where Italians found work was at the McCormick company. In 1873, the McCormick Reaper Works was a giant in the manufacturing of farm machinery. The first step to the infamous Haymarket Riot of 1886 began at McCormick when police clashed with workers from the Molders' Union who were advocating for an eight-hour workday. Decades later, McCormick changed its name to the International Harvester Company but the historic West Side factory at the junction of Blue Island and Western Avenues closed down by 1961. (Courtesy of ILHS.)

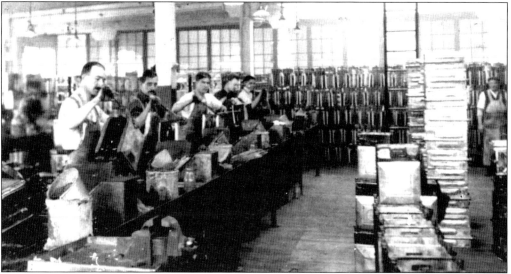

Immigrant labor provided the necessary ingredient for Chicago's industrial revolution. Mass production and the assembly-line system also made high productivity possible. In this lineup, Frank Lucatorto and Gino Silvestro work side by side to assemble meters on the southwest side. (Courtesy of Casa Italia.)

Living in the shadow of the McCormick company tower (center) are these residents of the Oakley Avenue neighborhood in 1958. Many residents of this community were from Northern Italian provinces. Some held liberal political ideas that opposed church and state authority in Italy and in the United States. Left-leaning workers from the Oakley neighborhood put their ideas into practice by advocating for union rights at the McCormick plant. (Courtesy of Casa Italia.)

The Crane Corporation, like McCormick Reaper Works, was established in Chicago just after the Civil War. At one Crane site, on Des Plaines Avenue between Lake and Randolph Streets, the Haymarket bombing took place in 1886. The Crane Corporation manufactured piping for large properties like the Joliet Prison, the Cook County Courthouse, and many prominent Chicago Loop skyscrapers. (Courtesy of ILHS, Gordon Means.)

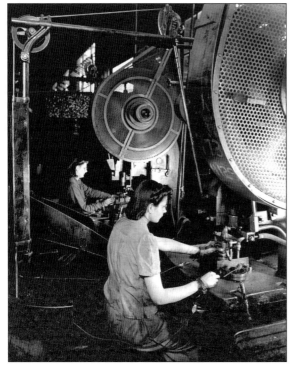

By the 1940s, the Crane Corporation employed more than 5,000 workers in its plant located at Kedzie Avenue near Forty-first Street. Like McCormick Reaper Works, the Crane Corporation plant employed many Italian Americans due to its location not far from the Oakley Avenue "colony." The woman at this press (foreground) had her wrists restrained by a cable to prevent her hands from being cut by the machine. (Courtesy of the Chicago History Museum, HB-07107-C, Hedrich-Bessing.)

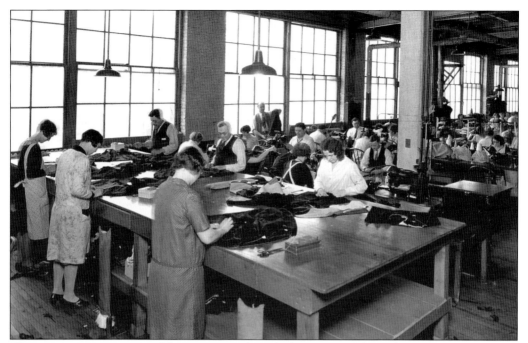
Chicago was a major center of the garment trade at the beginning of the 20th century. Men, women, and children assembled clothing on the old West Side. The Hart Schaffner and Marx Company, pictured here, was one of the largest garment factories in Chicago. (Courtesy of ILHS.)

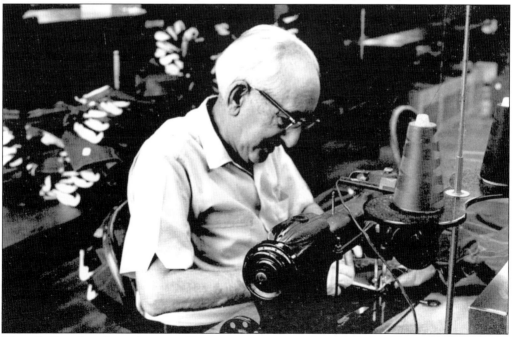
Many Italian, Jewish, and eastern European immigrants formed the backbone of the garment trade in Chicago from 1900 until World War II. At worktables on the city's Near West Side, immigrants did the pattern cutting, buttonhole work, basting, and pressing of ready-to-wear clothing. (Courtesy of UNITE HERE.)

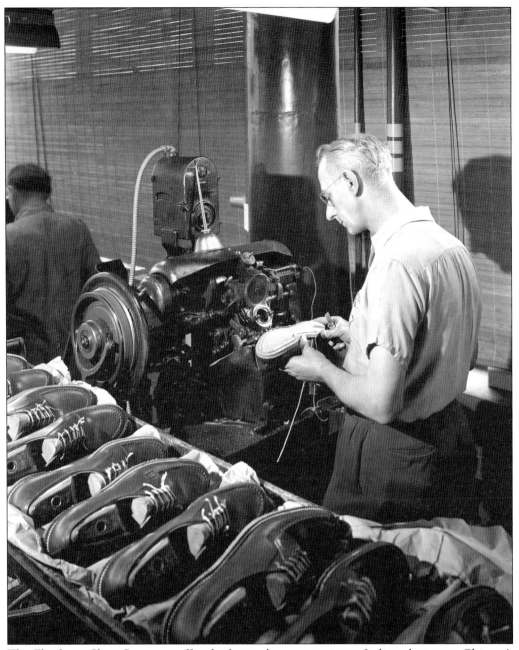

The Florsheim Shoe Company offered jobs in close proximity to Italians living on Chicago's West Side. Here a worker cobbles a sole at his workbench. (Courtesy of the Chicago History Museum 12633-H2, Hedrich-Bessing.)

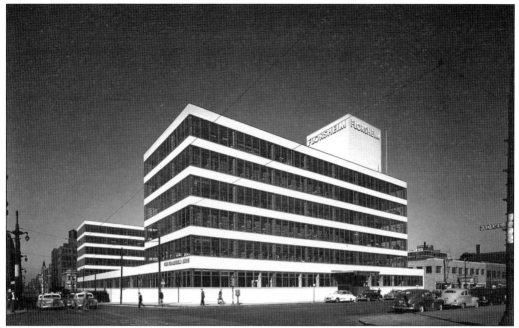

The Florsheim Shoe Company factory was situated near the city's garment district, St. Patrick's Catholic Church, and the Union Rail Station. This picture shows the airstream image and clean lines of the plant facade at Clinton and Adams Streets. (Courtesy of the Chicago History Museum 12633-A, Hedrich-Blessing.)

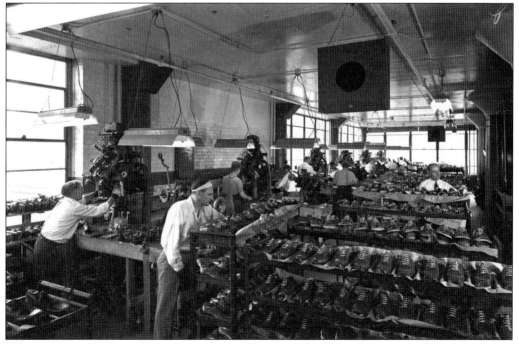

Workers at the Florsheim Shoe Company on Chicago's Near West Side operate belt conveyers in 1949. At this time, Florsheim Shoe Company was considered a state-of-the-art operation in the shoe industry. (Courtesy of the Chicago History Museum 12633.M, Hedrich-Blessing.)

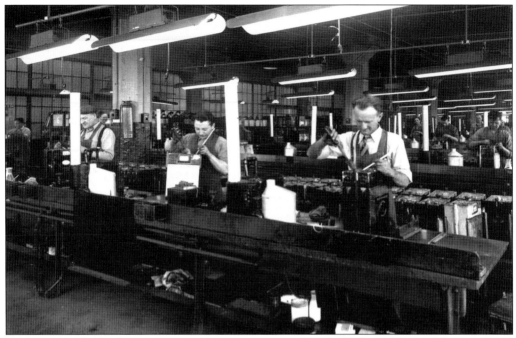

By the 1940s, the Bridgeport area in Chicago was an enclave for Italians. Many of them replaced longtime Irish residents who moved west. This photograph, donated by Leonora LiPuma, shows workers at the People's Gas Company on Pershing Road. (Courtesy of Casa Italia.)

Frank Ambrosio was a coal handler at the Commonwealth Edison Plant in Chicago. Born in Cosenza, Italy, in 1894, his first job as an immigrant was with the railroad in North Dakota. He returned to Italy during World War I and was drafted there. Ambrosio was captured by the Allied army and then held as a prisoner of war for several years. Following this episode, Ambrosio returned to Chicago and worked at Commonwealth Edison Plant until 1957. (Courtesy of Anthony Ambrosio.)

Many Italians found work at the Inland Steel Factory in Chicago Heights, a suburban ethnic enclave. Inland Steel produced railroad track and rebar. Shown here in 1945 is Joseph Bruti, who worked at Inland Steel. (Courtesy of Casa Italia.)

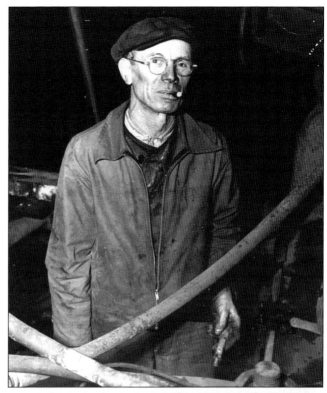

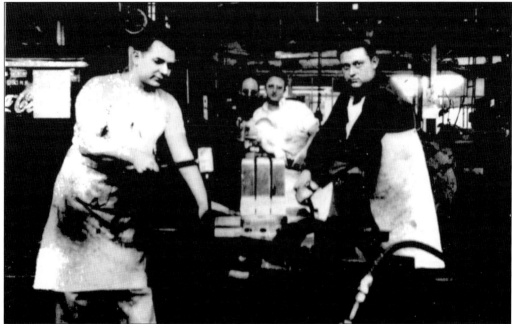

For decades, Chicago was a national center for steel production. In 1910, roughly 17,000 workers in the city were employed by the mills. By the 1970s, the number of steelworkers in Chicago grew to about 40,000. In this photograph, John Misasi (left) of Melrose Park molds a piece of metal. (Courtesy of Casa Italia.)

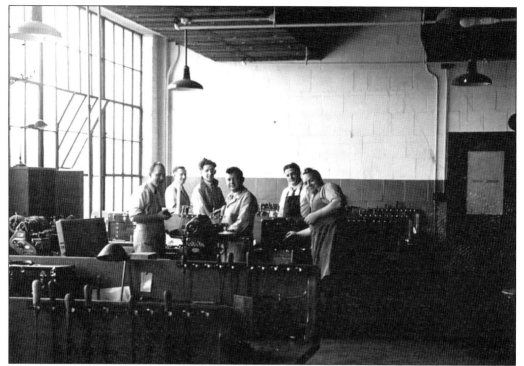

The Zenith Radio Corporation in its early days was based in Chicago at Austin Avenue and Dickens Street. Joseph LiPuma (second from the right) was part of this work crew in 1940. (Courtesy of Casa Italia.)

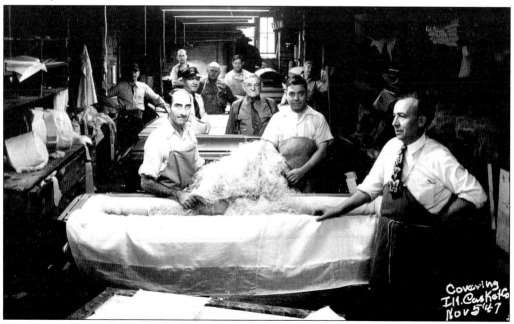

The Illinois Casket Company had a never-ending stream of customers, and this industry today still defies franchising and big corporations. Shown here in 1947 is Leonardo LaPlaca (front) with his work crew in the factory. (Courtesy of Casa Italia.)

Once upon a time, Chicago was the candy capital of America. More than a dozen big manufacturers were located in the city, but today only a few exist. Companies such as Brach's, Curtis, Johnson, Wrigley, and Holloway are no longer producing candy in Chicago. The candy industry once employed thousands of men and women on the production line. Standing proud are Gilda Dentino and her work team at the Bunte Brothers Candy Company in 1929. (Courtesy of Dominic Candeloro.)

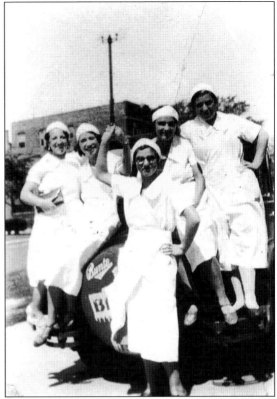

In 1960, members of the Ferrara family established a large-scale candy manufacturing plant at 7301 West Harrison Street in the village of Forest Park. This more-recent photograph features the factory set against heavy traffic along the Eisenhower Expressway. (Photograph by Peter N. Pero.)

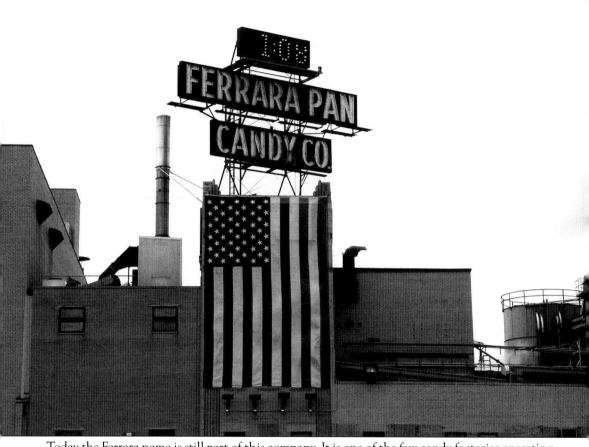

Today the Ferrara name is still part of this company. It is one of the few candy factories operating in Chicago with large-scale production. Ferrara has produced such legendary candies as Atomic Fireballs and Red Hots that past generations have enjoyed. (Photograph by Peter N. Pero.)

Six

RADICAL MOVEMENTS

At the beginning of the 20th century, the quality of life and work for many Italian immigrants, as well as for many working-class Americans, was declining. Government relief programs existed but could not directly improve wages. Solutions to the problem were proposed in Italy by Marxist thinkers and activists, even before the great wave of immigration to America. Their plans for worker control over the economy and government were exported to Chicago by the likes of Arturo Giovannitti, Giuseppe Bertelli, and Emilio Grandinetti. All three men advocated, agitated, and organized in Chicago.

Beyond the hard-line Marxists were progressive thinkers who created cooperative organizations to help immigrants share housing and jobs. Hull House on Halsted Street invited Italian artisans to sell their crafts in the art collective. *Cooperativas* from Cicero, Illinois, to Clinton, Indiana, proved that Italian immigrants could implement economic alternatives.

Chicago historian Bill Adelman points out that ethnic organizations in Chicago, like the German Turner Verein on Roosevelt Road and the Jewish Arbeiter Zeitung on Wells Street, worked in solidarity with the Italian Socialist Federation on Taylor Street. Also an active conduit of communication existed through the radical press. Publications like *La Parola dei Socialisti* and *Avanti* called for all workers in Chicago to unite.

Some critics believed that Italian immigrants were passive and disinterested in working-class politics, but historian Rudolf Vecoli concluded that Italians did not sit passively on the political sidelines. In fact, many Italians in Chicago joined working-class political movements and took positions of leadership. The American political experience produced not only solid citizens but socialists, Marxists, and communists as well. This chapter provides evidence.

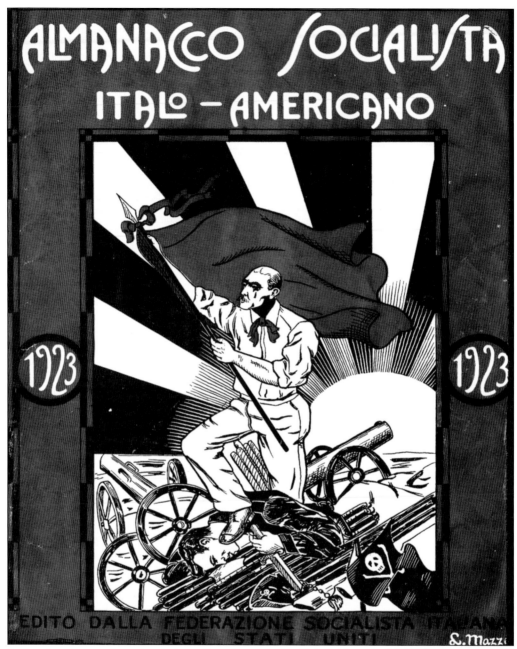

Italian immigrants brought their work, culture, and political ideas to Chicago. One long-held tradition was socialism. Italian radicals struggled against power and aristocracy in Italy and carried their ideology to America. Giuseppe Bertelli, for example, moved to Chicago in 1908 and created the Italian Socialist Federation, which printed a variety of radical publications. (Courtesy of the *Almanancco Socialista*, UIC Library.)

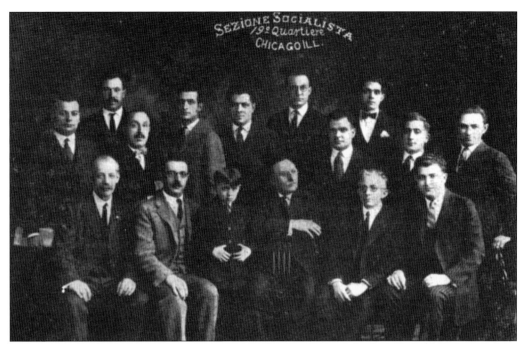

The Italian socialists were organized into neighborhood units in Chicago. Furthermore, there were branches for men, women, and children. Smartly dressed and highly educated, these immigrants were not the vagabond bomb throwers depicted in conservative newspapers. (Courtesy of the Immigrant History Research Center, University of Minnesota, 000911.)

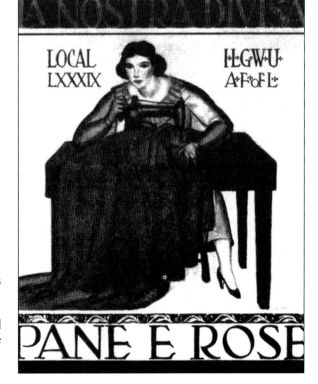

"Bread and Roses!" was a rallying cry for many labor organizers looking to improve the quality of life for all workers. This verse came from a poem by James Oppenheimer, "Hearts starve as well as bodies; give us bread but give us roses." The poem became a popular folk song and was translated into many languages. (Courtesy of the Immigrant History Research Center, University of Minnesota, 000910.)

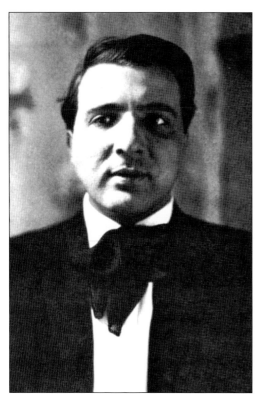

An Italian immigrant who became a legend in the huge 1912 textile strike in Lawrence, Massachusetts, was Arturo Giovannitti. He was accused of dynamite bombing in Lawrence and faced execution along with several other Italian strike organizers. Helen Keller and Eugene Debs came to the Italians' defense. In the end, Giovannitti was set free when the textile company admitted to staging the bombing. (Courtesy of the IALC.)

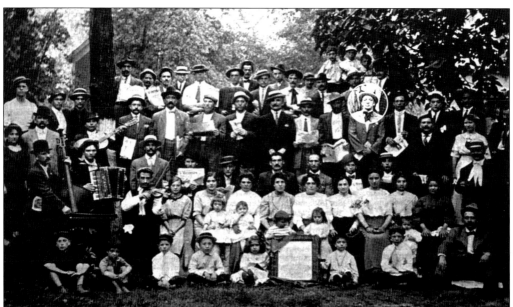

In this 1911 photograph, Arturo Giovannitti attends a picnic on Chicago's South Side. The socialists offered concerts, plays, raffles, debates, and other public attractions in order to attract new members. Giovannitti was a fiery orator, poet, and political organizer at these events. Circled in this photograph, he wears his flamboyant red scarf that was the trademark for many radicals of the day. (Courtesy of IALC.)

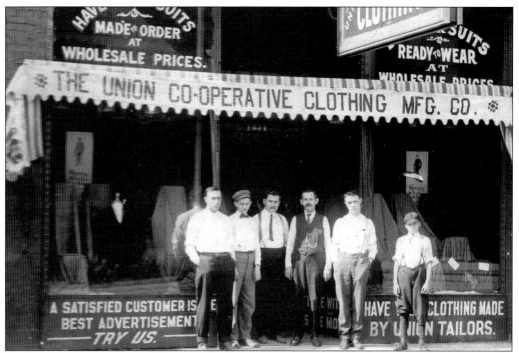

A socialist enterprise that reached into communities throughout the Midwest was the cooperative store. By pooling their labor and resources, these Italian and Jewish tailors could sell merchandise for less. This 1916 garment shop was located at 1354 West Taylor Street in the heart of Little Italy. (Courtesy of Casa Italia.)

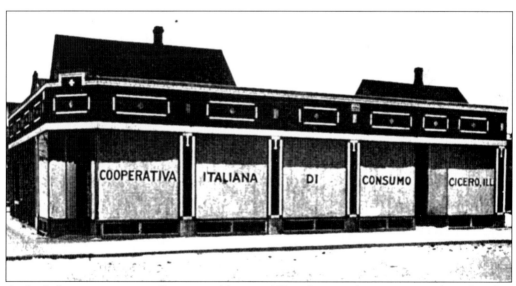

At this Italian cooperative in Cicero, neighbors could buy shares in the operation and merchandise was purchased at wholesale prices. These co-ops were not limited to big cities. Italians in Clinton, Indiana, for example, established a co-op in 1896. The cooperative movement spread like wildfire across the prairie. Even today many food, housing, and car-sharing cooperatives exist in Chicago. They take inspiration from the grassroots organizations of 100 years ago. (Courtesy of IALC.)

La Cooperativa Editrice della F. S. I.
Italian Labor Publishing Co.

La Italian Labor Publishing Co., è una istituzione tipografica, la quale fu fondata nel 1913, per iniziativa di alcuni nostri solerti compagni, ai quali costò un'immensità di sacrifici, prima che si stabilisse per funzionare per lo scopo per cui la fondarono.

Lo scopo della fondazione della Italian Labor Publishing Co., era di provvedere la Federazione Socialista Italiana, di un impianto tipografico per la pubblicazione del nostro giornale, libri, opuscoli, ecc., onde aiutare la nostra Federazione stessa, nella propagazione del verbo del Socialismo e i principii prettamente internazionalisti tra gli emigrati italiani in questo paese.

nostre attività onde raggiungere quanto prima il punto di vedere appagato il desiderio di coloro che per essa dettero danaro, tempo ed energie intellettuali. Perciò dobbiamo andare avanti. Ci abbisogna una casa propria; dei locali più vasti che corrispondano alle esigenze del nostro sviluppo e cresciute attività e lavoreremo senza dubbio, la casa forse prima che termini l'anno corrente, sarà un fatto compiuto, perchè non ci mancherà certamente la cooperazione dei compagni tutti e simpatizzanti a sì nobile e grande impresa.

E' nostra ferma convinzione, che da questo sforzo collet-

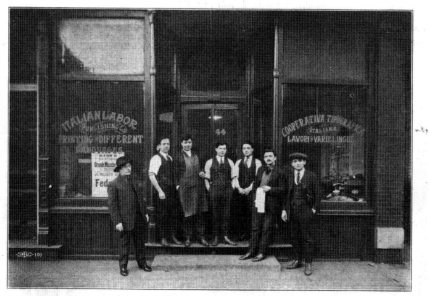

Gli operai della Cooperativa Editrice e impiegati presso il giornale della Federazione Socialista Italiana

Cosicchè quando la tipografia nostra sarà riscattata dalle ipoteche sui macchinari avrà compiuta la propria missione, e allora passerà alla Federazione, cioè alla comunità Socialista. Recentemente è fondata su basi cooperativistiche prettamente Socialistiche; le azioni non fruttano interessi; gli azionisti sono quasi tutti compagni e simpatizzanti.

La Italian Labor Publishing Co., si è affermata come una delle più grandi, una delle più conosciute aziende tipografiche italiane in America.

I lavori che eseguisce sono varii e multiformi; le ordinazioni di lavori continuano a mantenersi ad un livello tale superiore alle nostre possibilità produttrici.

Questo non dice che dobbiamo fermarci e di rallentare il nostro cammino, al contrario impone l'intensificazione delle

tivo ne uscirà senza fallo il bisettimanale e quindi, coi tipi della nostra tipografia, sarà dato alla luce il tanto agognato quotidiano Socialista dei Lavoratori Italiani d'America.

Ecco in poche parole la storia del nostro passato e la prospettiva del promettente nostro avvenire.

E' così grande l'affidamento che noi facciamo sul nostro Ideale, su questa nostra istituzione, che ci rende orgogliosi di esserne cooperatori ed amministratori, più orgogliosi ancora quando pensiamo che essa fornirà alla Federazione Socialista Italiana degli Stati Uniti un efficace congegno di propaganda pel Socialismo.

LORENZO BELLANDI, Manager

The Italian Socialist Federation was located in the heart of Little Italy. It was a beehive of activity in support of workers' rights and political action. Meetings and printing operations were based at this site. Today this old storefront at 1044 West Taylor Street is a hair salon, albeit owned by an Italian proprietor. (Courtesy of the *Almanancco Socialista*, UIC Library.)

The Federazione Socialista in Chicago was led by Giuseppe Bertelli. He was an ardent socialist who fled from Trieste, Italy, due to his political activities. In Chicago, Bertelli edited a newspaper called *La Parola del Popolo*, or "voice of the people," as shown in this advertisement for the paper. (Courtesy of Casa Italia.)

LA PAROLA DEL POPOLO

ORGANO UFFICIALE DELLA

Federazione Socialista Italiana del Socialist Party

Unico Giornale Socialista Italiano in America;
consolidato con "La Parola dei Socialisti"
"La Parola Proletaria" La Fiaccola"
e "L' Avanti"

Abbonamento Annuo $2.00 Semestrale $1.00

Uffici di Redazione ed Amministrazione:
1044 WEST TAYLOR STREET
CHICAGO, ILLINOIS

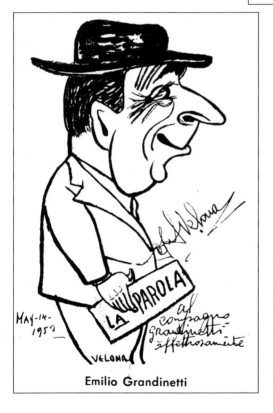

Emilio Grandinetti

In this caricature is Emilio Grandinetti, a colorful member of the Italian socialist movement. In Italy, he was sentenced to prison for writing a critical newspaper story about the royal family. Grandinetti immigrated to Chicago where he wrote for the Italian socialist press. The early days of the paper were miserly. The editors had no money for coal, so they heated the office by burning newsprint in a stove. (Courtesy of La Parola.)

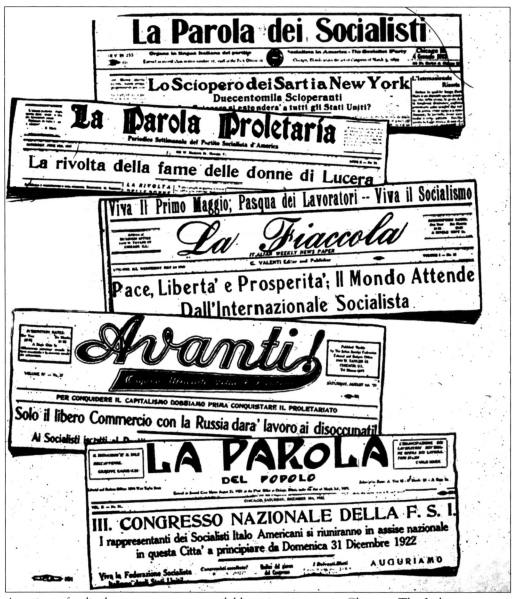

A variety of radical newspapers were available to immigrants in Chicago. The Italian press was open to workers of any ethnicity, and some pages were translated into a variety of languages. Beyond Chicago, *La Parola dei Socialisti* had subscribers in Indiana, West Virginia, and Pennsylvania. A subscription was $1 per year. (Courtesy of La Parola del Popolo.)

LA PAROLA DEI SOCIALISTI

PERIODICO SETTIMANALE

ORGANO IN LINGUA ITALIANA DEL PARTITO SOCIALISTA IN AMERICA (The Socialist Party)

ABBONAMENTI	DIREZIONE ED AMMINISTRAZIONE	INSERZIONI
UN ANNO $1.00 SEI MESI $0.60 ESTERO IL DOPPIO	145 BLUE ISLAND AVE., CHICAGO, ILLINOIS.	PREZZI DA CONVENIRSI NON SI ACCETTANO INSERZIONI DI BANCHE E DI ALTRE ISTITUZIONI NON CONSONE AGLI INTERESSI OPERAI

ANNO I. — Chicago, Ill., 17 Febbraio 1908. — **NUM. 1.**

LA PRIMA PAROLA

Da circa sei mesi i socialisti Italiani irreggimentarsi come un uomo solo e formare un unico partito: il partito socialista, senza aggettivi.

In America questo partito esiste, è forte di diecine di migliaia di aderenti, è riconosciuto da tutti i socialisti delle altre parti del mondo; a differenza degli altri nuclei socialisti esistenti in questo paese, riconosciuti soltanto da essi stessi. È l'unico Partito Socialista in America, rappresentante **L'Internazionale Socialista** che risiede a Bruxelles.

In esso, come nel Partito Socialista in Italia, anche qui nel Partito Socialista, i sindacalisti alla Labriola convivono coi riformisti alla Turati, e, come in Italia sarebbero stati acerbamente biasimati quei compagni che per puntiglio di tendenze avessero scisso il partito, così in America sono da biasimare quei compagni che per lo stesso puntiglio una deplorevole scissione mantengono.

Tutti uniti, se socialisti, questa è la nostra divisa.

Compagni!

Ecco lo scopo, la ragion d'essere del Bruxelles esso sorge per chiamare sotto un'unica e naturale bandiera tutti i compagni, di qualunque parte del mondo essi siano, sparsi in queste terre.

Non rancori tendenzaioli e personali, non acredini, non polemica. Appello fraterno a tutti i fratelli, propaganda di idee, lotta feconda contro il nemico comune: la borghesia, scuola elementare dei nostri principi.

Stringiamo le file per l'attacco, siamo sparpagliati, non possiamo attaccare e tanto meno vincere così. Viva il Socia-

hands, as a result, were frost-bitten. The work of the *Parola*, however, was such that through its efforts, the Italian Socialist Federation, affiliated with the Socialist Party of America, was formed. Giuseppe Bertelli, who was its founder and first director, hailed from Trieste, where he had been editor of *Il Lavoratore*, a socialist weekly who published in their localities small papers against the war. Unfortunately, these papers disappeared during the war, and all the socialist forces united behind *La Parola dei Socialisti*. Molinari, "the poor people's doctor," and Lucidi, moved to Chicago. The first was the Editor of the journal for a long time, while the second

Here is the front page of the first edition of *La Parola dei Socialisti*, printed at 145 South Blue Island Avenue in 1908. The newspaper refused to support the military cause during World War I and was banned from the U.S. mail by the federal government. Rather than cooperate, *La Parola dei Socialisti* changed its name, and the newspaper was shipped in crates marked as "canned tomatoes." (Courtesy of La Parola del Popolo.)

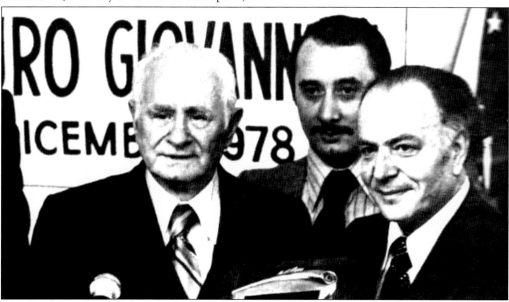

The last editor of *La Parola del Popolo* news was Egidio Clemente. He joined the staff in 1929, but by 1970, most of his old comrades had passed away. Clemente was left to run the publication single-handedly. At 80 years old, he wrote stories, set type by hand, and mailed the publication to subscribers. Here Clemente (left) receives a lifetime achievement award through the City University of New York in 1978. Poet and professor Joseph Tusiani (right) presents the plaque in this photograph. (Courtesy of La Parola del Popolo.)

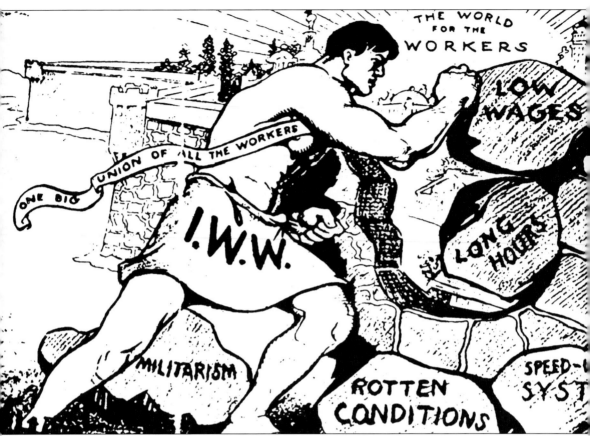

The International Workers of the World (IWW) was a colorful radical organization. Born in Chicago in 1905, the IWW welcomed workers of all nationalities with the slogan One Big Union. Arturo Giovannitti, Emilio Grandinetti, Joe Ettor, and Carlo Tresca translated the IWW credo to Italian immigrants. (Courtesy of IWW.)

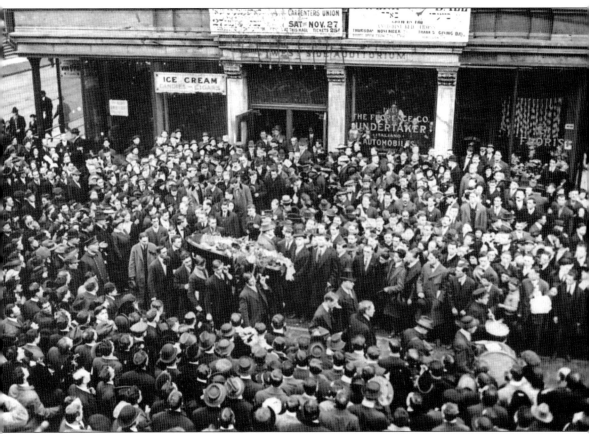

Joe Hill was an IWW troubadour. He wrote songs like "Rebel Girl" and "Pie in the Sky" to persuade workers and children to join the union cause. In 1915, Hill was accused of robbery and murder in Utah. He was executed by a firing squad, and his body was shipped to Chicago. The funeral was held at an Italian funeral home (center window) at Taylor Street and Racine Avenue, where the carpenters' union hall was located. In this photograph, more than 5,000 mourners march through Little Italy on Thanksgiving Day 1915. Eulogies for Hill were given in nine languages. (Courtesy of the ILHS.)

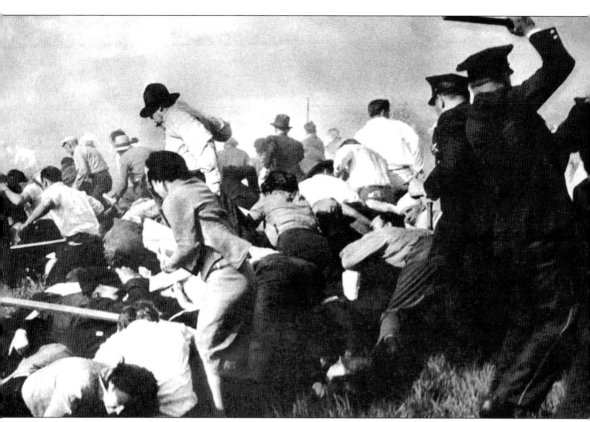
An infamous event in Chicago labor history was the Memorial Day Massacre of 1937. The U.S. Steel Corporation agreed to a union contract but Republic and Inland Steel companies would not. When Republic Steel hired nonunion workers, a rally was staged by the union in an open field at 117th Street in South Chicago. (Courtesy of the USW.)

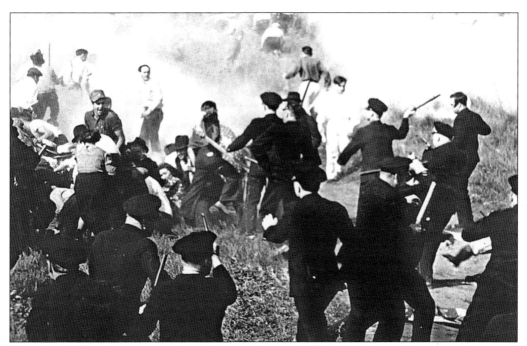

More than 200 policemen met the strikers in the open field and fired pistol shots into the crowd. There were 10 unionists killed from gunshots to the back and side; 30 marchers were seriously wounded. (Courtesy of the USW.)

The LaFollette Commission was formed in 1937 to investigate the riot. They upheld the union's right to picket and blamed the police for excessive violence. This photograph from the Lafollette Commission hearing shows a Hull House social worker who was aiding the wounded strikers that day. She was arrested and put in a police paddy wagon with the injured victims. (Courtesy of the Chicago History Museum, i50126.)

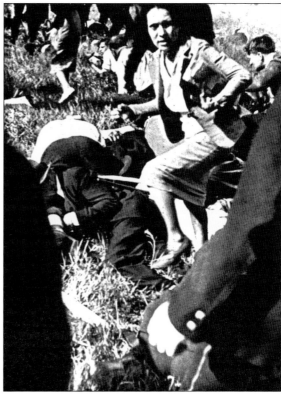

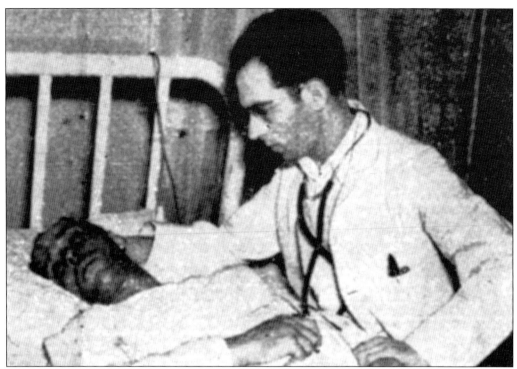

Anthony Tagliori was one of the unionists who died in the Memorial Day Massacre. This photograph shows him being treated at South Chicago Hospital prior to his death. (Courtesy of the Chicago History Museum, i51684.)

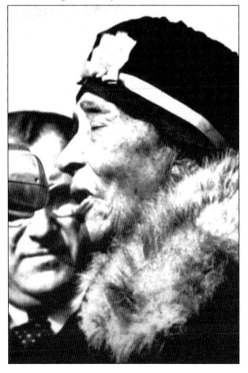

Lucy Parsons and her husband, Albert Parsons, made history at Chicago's Haymarket Riot in 1886. Lucy was a tireless fighter for workers' rights and racial equality. In this photograph from the 1940s, Parsons speaks at a labor rally backed by Tony Cavorso of the United Auto Workers' Union (UAW). Parsons died at the age of 89 and was buried in Waldheim Cemetery near Emma Goldman and the graves of 25 other radical dissenters in Chicago history. (Courtesy of IALC.)

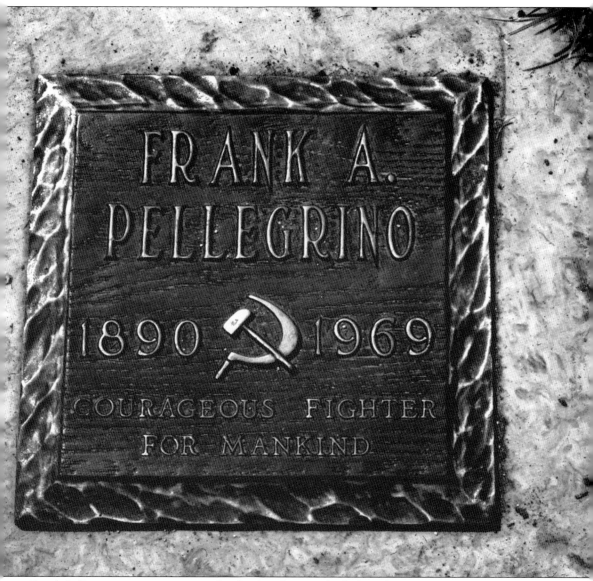

Frank Pellegrino was an organizer for the Amalgamated Clothing Workers' Union and became a charter member of the American Communist Party in 1919. According to historian William Adelman, the Pellegrino family requested that a hammer and sickle be placed on Frank's gravestone located near the Haymarket martyrs' graves. Pellegrino's wife claimed that the cemetery charged twice the usual rate to engrave this controversial headstone. (Photograph by Peter N. Pero.)

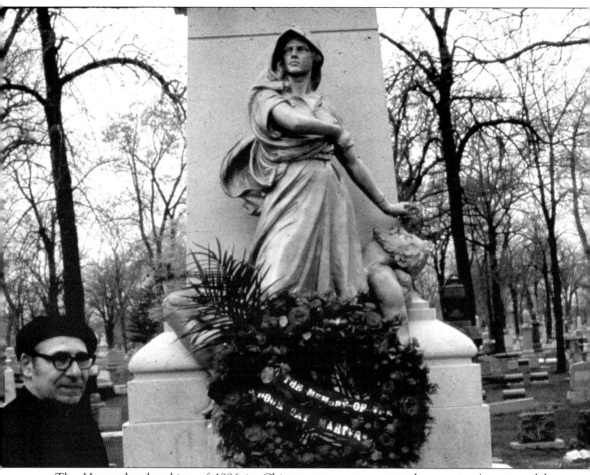

The Haymarket bombing of 1886 in Chicago was a monumental event in American labor history. Eight political anarchists were accused of a bombing, and four were hanged at the old Cook County jail. Every year the Illinois Labor History Society commemorates Haymarket. In this photograph is Joseph Giganti, a member of the Chicago City Colleges Teachers' Union who helped place a wreath on the Haymarket graves at the old German Waldheim Cemetery in Forest Park. (Courtesy of IALC.)

Seven
Trade Unionism

From 1890 to 1940, many working Italians formed or joined trade unions. In this sense, the political agenda of the radical left wing was achieved. Industries with the most dangerous or arduous work for immigrants provided attractive recruiting grounds for the unions.

As early as the 19th century, coal miners, railroad workers, and other laborers in heavy industry discovered the benefits of unionization. By the middle of the 20th century, nearly all trades got involved. The barbers, mosaic workers, sprinkler fitters, upholsterers, sewer workers, photographers, laundry drivers, cigar rollers, elevator operators, funeral workers, armored car drivers, and even newsboys all became unionized.

The construction trades provided a relatively open door for Italian immigrants. It was also a likely place for them to encounter unions. The hod carriers, masons, carpenters, and electricians unions offered the attraction of craft unionism. Another area with strong Italian participation was in the garment trades. Here the Amalgamated Clothing Workers' Union and International Ladies' Garment Workers Union held Italians in both membership and leadership.

With the advent of the Congress of Industrial Organization (CIO) in 1935, few workers were left behind. Italian labor organizers for the United Auto Workers' Union (UAW) extended their reach to both skilled and unskilled workers.

Italian workers in the steel industry rallied around the United Steel Workers' Union (USW). The Inland Steel Company had a huge plant in Chicago Heights, which was a community with a large percentage of Italian residents. Also thousands of Italians could be found working at the Republic Steel and U.S. Steel plants on Chicago's South Side.

Following World War II, new sectors of the U.S. economy became unionized. Workers in white-collar sectors, such as retailing and government work, joined the cause. The following chapter and photographs chronicle a parade of Italians in the trade union movement.

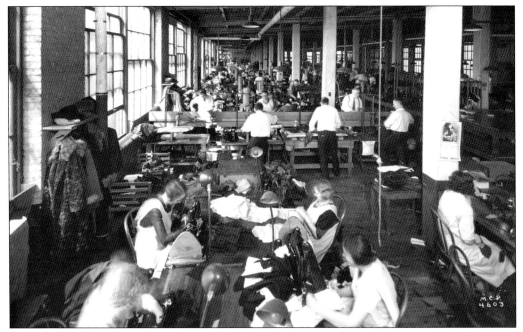

At the opening of the 20th century, the garment industry was one of the largest employers of immigrant labor in Chicago. According to historian Eugene Miller, workers from 16 ethnic language groups were employed in these factories. One Italian group of coat makers could not communicate in English with the city labor group. These garment workers from Tuscany, Piedmont, Sicily, and Sardinia formed a local chapter, conducted meetings, and recorded the proceedings in Italian. Historians are fortunate that these records exist. (Courtesy of ILHS.)

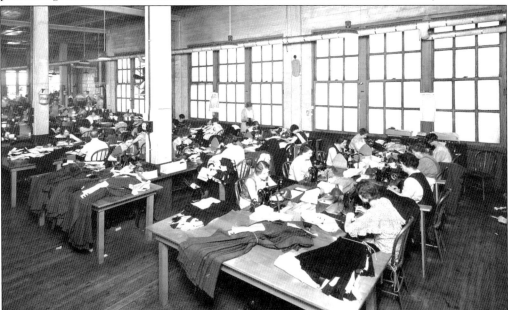

The piecework system paid an immigrant based on performance. Speed and output were critical to earning a paycheck. As much as they needed the jobs, immigrants began to protest against working conditions in the needle trades. (Courtesy of ILHS.)

SARTI ITALIANI DI CHICAGO

Le condizioni nostre nelle fattorie sono diventate insopportabili. CI FAN LAVORARE SEMPRE PIU' E CI PAGANO SEMPRE MENO. I sistemi a base di multe, di libro nero, di lavoro a contratto, di licenziamenti per capriccio han fatto adagio adagio della utile e laboriosa categoria dei sarti una classe di schiavi.

CIO' NON PUO', NE DEVE DURARE. Quindicimila sarti, organizzati han chiesto ai padroni condizioni di lavoro più umane ed una paga decente, avvertendoli che se Lunedì prossimo non risponderanno favorevolmente, proclameranno lo sciopero generale PER BATTERSI FINO A VITTORIA COMPLETA.

Mai come questa volta la battaglia si è presentata in condizioni migliori. NOI VINCEREMO!

SARTI ITALIANI. Noi non saremo alla coda delle altre nazionalità. Noi dobbiamo provare che nelle lotte per l'interesse comune e per il comune riscatto gli italiani lavoranti dell'abito sanno formare una FALANGE SOLA COI LORO COMPAGNI DI LAVORO.

Domenica 26 corr. alle ore 10 a. m.
AVRA' LUOGO
UN GRANDE COMIZIO PER I SARTI ITALIANI
ALLA BOWEN HALL DELLA
HULL HOUSE (Polk and Halsted Sts.)

Saranno presenti: il Presidente Internazionale della **Amalgamated Clothing Workers of America, Sidney Hillman** e la Signorina **Bessie Abramovitz**, rappresentante delle donne nel G. E. B. Presiedera' il Presidente della Joint Board A. C. W. of A.: **Anzuino D. Marimpietri**.

PARLERANNO —
EMILIO GRANDINETTI e GIUSEPPE BERTELLI

Venite tutti, se avete interesse al vostro lavoro, alla sorgente del vostro guadagno. Mancando oggi non è soltanto pigrizia e negligenza, è qualcosa di peggio.

Amalgamated Clothing Workers of America

As early as 1910, garment workers staged the first massive walkout at the Hart Schaffner and Marx Company in Chicago's West Loop. This 6,000-worker walkout grew into a citywide strike of nearly 25,000 garment workers. This poster lists both Italian and Jewish labor leaders, male as well as female, speaking at Hull House in support of a garment workers' union. (Courtesy of the Amalgamated Clothing Workers'.)

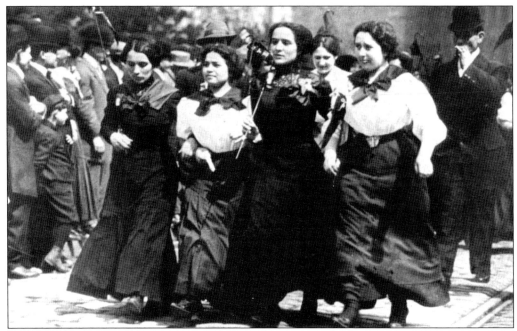

In some of the clothing factories, more women than men worked in the shops. During the 1910 strike, women showed strong leadership. Clara Masilotti was an Italian worker with fluency in both English and Italian. She was one of the first employees to strike extorting her coworkers: "You ladies cannot continue to work for twelve cents per coat and I cannot baste 35 coats in a day!" (Courtesy of the Public Affairs Press.)

Louis Chiostra was an ardent labor organizer. He came to Chicago from Tuscany in 1908 and joined forces with Anzuino Marimpietri to build a strong union for garment workers. He allied with Jewish leaders like Sidney Hillman and Jacob Patofsky to build the Amalgamated Clothing Workers' Union. A radical spokesman until the day he died, Chiostra spoke out against politicians like Dwight Eisenhower and Barry Goldwater when they suggested cuts to the social security and medicare programs in America. (Courtesy of La Parola del Popolo.)

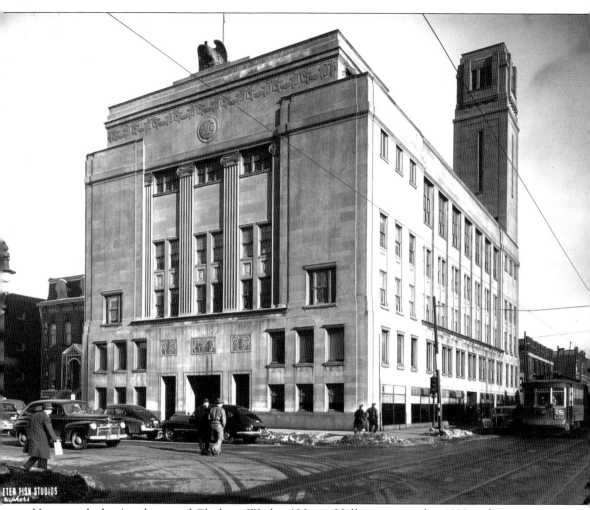

Here stands the Amalgamated Clothing Workers' Union Hall, constructed in 1928 at the corner of Ashland Avenue and Van Buren Streets. This labor center offered cradle-to-grave benefits under one roof. A childcare center, bowling alley, medical clinic, and senior retiree center were housed in this building. Today the old Amalgamated hall is part of a larger union called UNITE HERE, which occupies this historic building on Chicago's "union row." (Courtesy of ILHS.)

Around 1900, many industrial workers could not open a bank account due to the fact that many did not own homes or much collateral. The garment union took the risk of backing blue-collar workers by creating a bank backed by union funds. Here is a photograph of the Amalgamated Trust and Savings Bank during its grand opening in 1923. (Courtesy of the ILHS.)

By the 1970s, the old Amalgamated Trust and Savings Bank moved to modern quarters at State and Monroe Streets in Chicago's Loop. Today it is a repository of assets for many unions in Chicagoland. (Courtesy of IALC.)

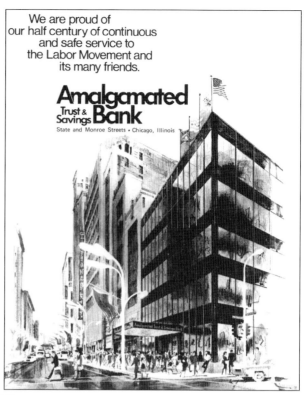

Truck drivers led an independent struggle for recognition as the International Brotherhood of Teamsters' Union in Chicago. Joseph Caracci stands to the right with a fellow driver as photographed at 1708 West Taylor Street in the heart of Little Italy. (Courtesy of Jeff Caracci.)

In 1935, the CIO came into fruition. This umbrella organization included workers from all sectors of heavy industry that had previously been ignored by the American Federation of Labor. (Courtesy of IALC.)

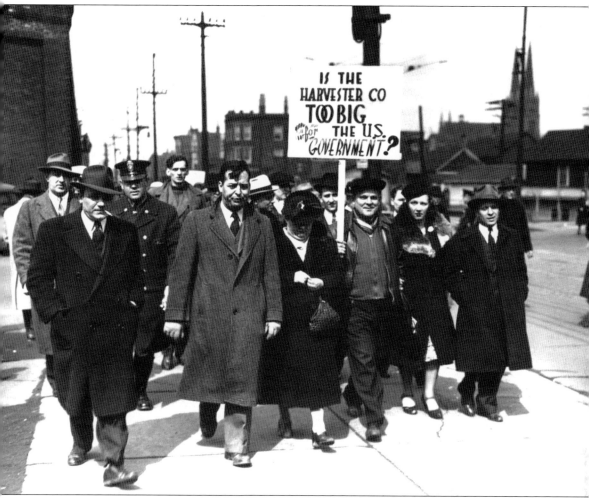

One of the first groups to gain momentum under the CIO was a sector of workers in the automotive industry. The International Harvester factory, at Blue Island and Western Avenues, employed a large number of workers in the manufacturing of tractors and farm implements. During World War II, employees complained that the company needed to comply with federal wage and price controls. In 1941, men and women in this photograph protest along Damen Avenue near Cermak Road followed by a police escort. (Courtesy of the Chicago History Museum, i17213.)

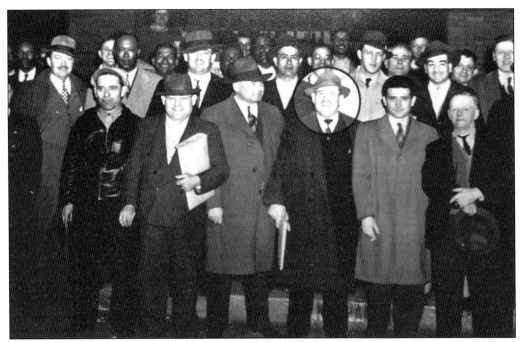

Anthony Cavorso (circled in this photograph) was a dedicated and popular organizer for the UAW. Cavorso is shown here in 1952 with fellow workers in the Oakley Avenue Neighborhood. (Courtesy of the IALC.)

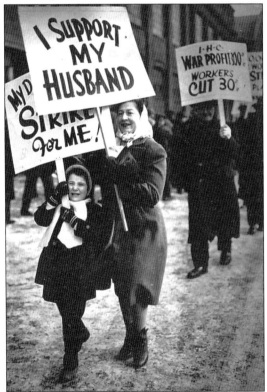

Cavorso's wife and child marched to support the autoworkers. Both are pictured here during a wintry day at the International Harvester plant on Chicago's Near West Side. (Courtesy of the IALC.)

Metalworkers at the Revere Copper and Brass Company protest wage cuts here. Crouched in the front row of this photograph is Anthony Audia, a member of the first Chicago UAW local chapter in 1928. (Courtesy of Tony Audia.)

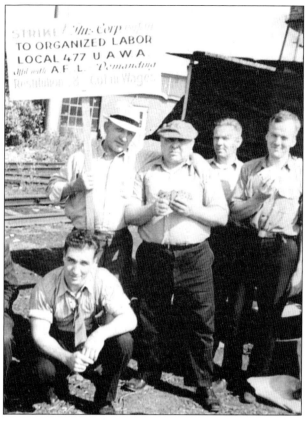

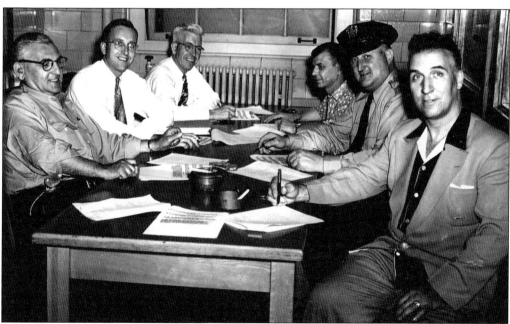

Anthony Audia organized plant guards here in 1956. He was an agent to more than 2,500 contract settlements during his union career. (Courtesy of Tony Audia.)

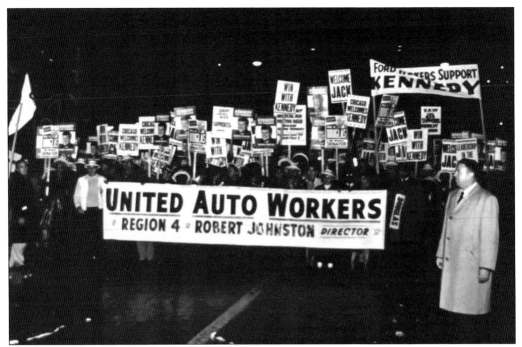

Autoworkers rallied here in support of John F. Kennedy for president. His administration was generally favorable toward labor reforms from 1960 to 1963. (Courtesy of IALC.)

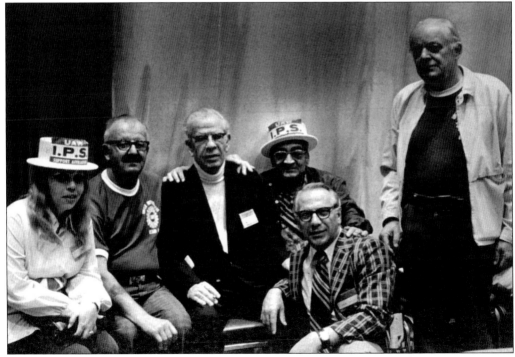

Albert Verri was a working-class intellectual. After retiring from the autoworkers' union in the 1970s, Verri taught labor history classes at Roosevelt University in Chicago. In this photograph at a labor convention in 1974, Verri is kneeling in the front row. (Courtesy of Albert Verri.)

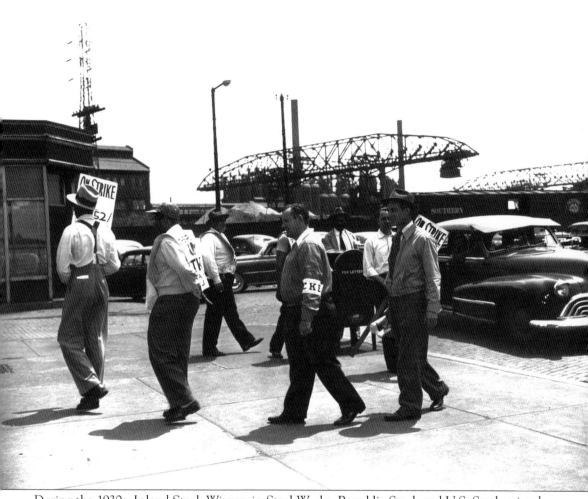

During the 1930s, Inland Steel, Wisconsin Steel Works, Republic Steel, and U.S. Steel resisted unionization of their factories. After a long and bitter battle, steelworkers eventually won a relatively high wage level and benefits too. In this photograph, the USW stages a picket line on 89th Street on Chicago's South Side. (Courtesy of Chicago History Museum, ICHI-51685.)

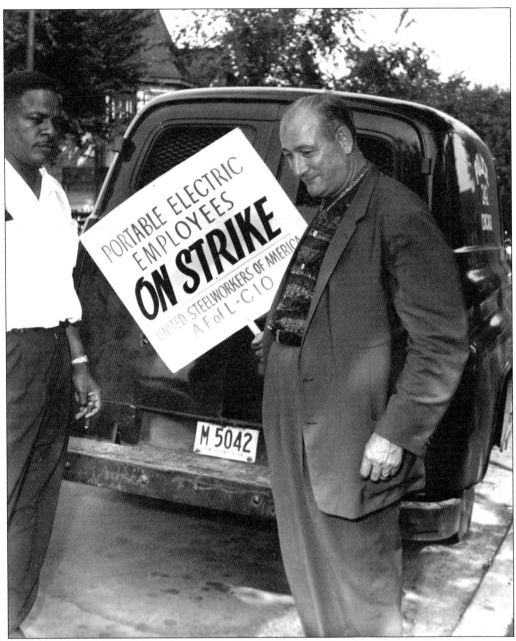

Joseph Germano was a member of the Steel Workers Organizing Committee during the rough-and-ready years when steelworkers tried to unionize in Chicago. When the union finally won recognition, Germano was in charge of organizing northeastern Illinois and northern Indiana. Pictured here in 1956, Germano walks a picket line just behind a Chicago Police paddy wagon. (Courtesy of the Chicago History Museum, i51692, Daily News.)

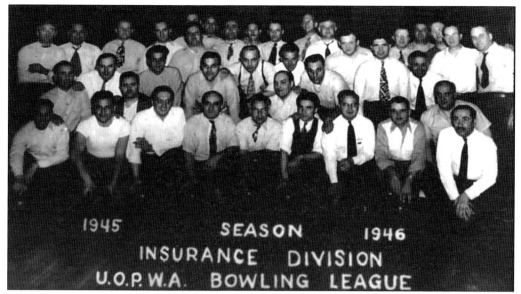

One area of growth for organized labor today is in the field of white-collar work. As early as 1945 a union of clerks and office workers was formed in Chicago. This group included librarians, social workers, and even insurance agents. Pictured in this photograph is a union outing for insurance workers. (Courtesy of IALC.)

Joseph Rovai was an early member of the insurance workers group. He later moved to the American Federation of State, County, and Municipal Employees Union. Rovai is shown (second from left) in this picture taken at the Illinois Federation of Labor convention where he was an officer for more than 20 years. (Courtesy of Joe Rovai.)

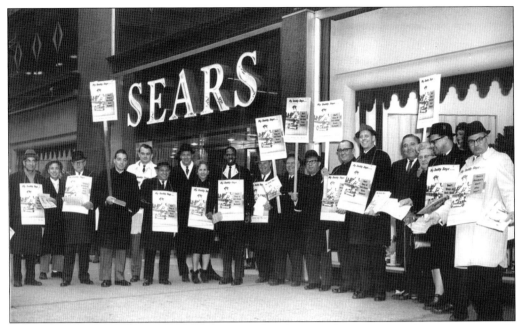

Retailing is a huge area of growth for unions today. As more Americans go shopping, more jobs are created, although wages in the retail sector have remained historically low. Joseph Ungari (far right) was a pioneer who did something about this trend. He recruited Loop retail workers into a union. Ungari marches with fellow workers in front of the Sears store on State Street in this 1962 photograph. (Courtesy of the Chicago History Museum, i51570, Burke and Dean.)

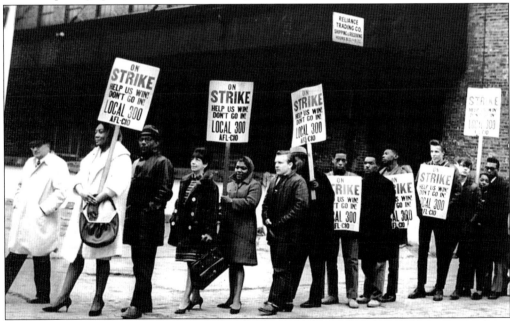

Joe Ungari began his career at the National Food Store in 1944. Frustrated by conditions there, Ungari united clerks and managers into a successful retail union. He went on to form labor groups at the Reliance Trading Company (shown above), Boston Store, Montgomery Wards, and at Polk Brothers in Chicago. Ungari leads this picket line on the left. (Courtesy of IALC.)

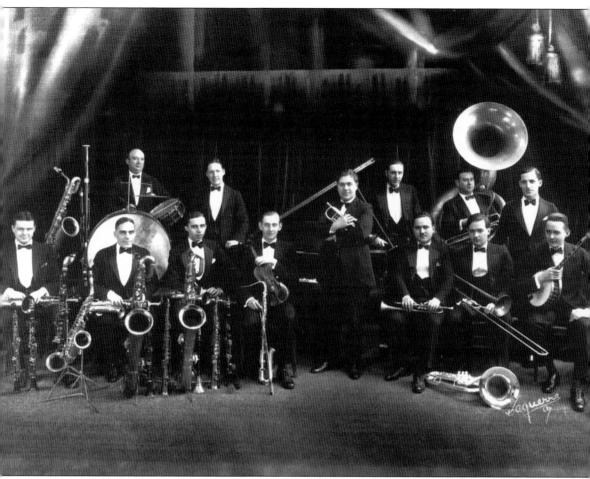

Musicians in the 1920s traditionally worked part-time at any wage rate they could earn. They played in saloons, churches, dance halls, parades, and restaurants. Low pay or no pay was typical, but even worse, musicians were being replaced by radio and recorded music. They needed a union. (Courtesy of Casa Italia.)

A strong voice in defense of musicians was James C. Petrillo. He grew up on the Near West Side of Chicago and, like Benny Goodman, took music lessons at Hull House on Halsted Street. At 14 years old, Petrillo played trumpet in a dance band. (Courtesy of Bookman Associates.)

The MUSICIANS and PETRILLO

By 1944, Petrillo had become the undisputed head of the American Federation of Musicians. He fought against U.S. vice president Charles Dawes and the Mussolini government for using nonunion musicians at public rallies and ceremonies. Petrillo even fought against recorded music in movie theaters where live bands could be used instead. (Courtesy of the American Federation of Musicians.)

Petrillo was criticized for his union policies. He fought for musicians' rights to a contract and royalties from record companies. He strongly opposed the use of "canned music" to circumvent the use of live performers. (Courtesy of American Federation of Musicians.)

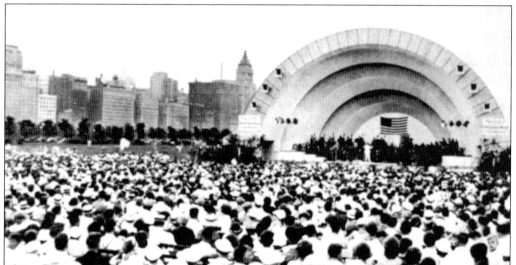

Petrillo is best remembered today for the free concerts that he helped to establish during the 1930s in Chicago. The union offered summer concerts in this band shell at the south end of Grant Park. The concerts provided entertainment for out-of-work citizens and jobs for musicians during an economic depression. (Courtesy of IALC.)

In 1978, a new music stage was constructed in Grant Park. It is still called the Petrillo Bandshell. On this stage, gospel, rock, blues, jazz, and symphony concerts are offered during free public festivals. One writer called the new bandshell a "poor man's Ravinia" in downtown Chicago. (Photograph by Peter N. Pero.)

Eight
LABOR AND POLITICS

"Working in both labor and politics is like walking on a razor; if you fall you fail," once said Prof. Stanley Rosen of the Institute of Labor and Industrial Relations at the University of Illinois at Chicago.

As early as the presidency of Theodore Roosevelt in the United States, labor advocates have been involved in politics on national, state, and local levels. Samuel Gompers, Eugene Debs, A. Phillip Randolph, Florence Kelly, Saul Alinsky, and other activists pulled political "levers" for labor. By the 1950s, the cries of the Marxists and socialists gave way to more moderate voices who sought compromise with the U.S. political system. Italian reformers learned the art of compromise with Jewish, Polish, Latino, African American, and other ethnic politicians.

The art of political advocacy has a long history in Chicago. In this city, *clout* was not a word created by political scientists but by practitioners in the street. A symbiosis existed between labor lobbyists and political parties in that both sides sought to protect their interests, that is votes for politicians and reforms for labor. In this equation, there was sometimes room for corruption.

When the political process broke down, there were pickets and protests, witch hunts, and boycotts. Many Italian activists played their roles. The following chapter provides a photographic political pageant.

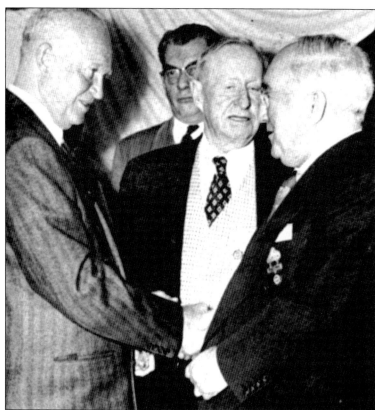

Here Republican president, Dwight Eisenhower (far left) meets American Federation of Musicians president James Petrillo (far right) at the American Federation of Labor convention. These two bosses did not always see eye to eye. (Courtesy of Bookman Associates.)

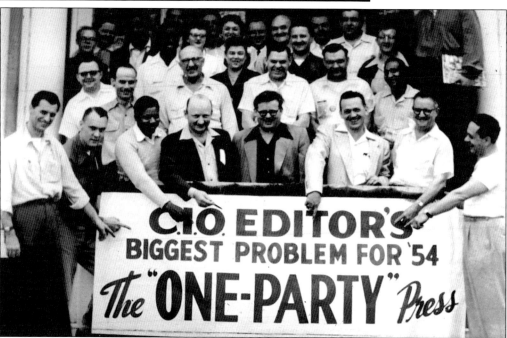

In 1954, a big problem facing the CIO was the government's drift to the political right. Here editors protest this conservative trend with a pressman's banner. (Courtesy of IALC.)

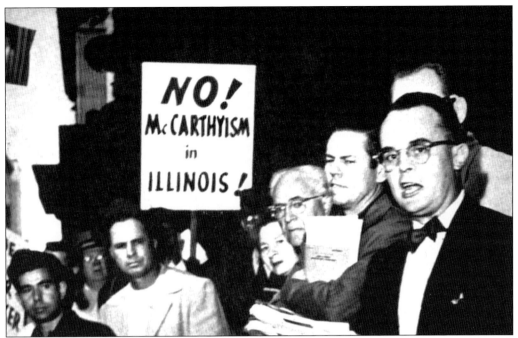

The climate in Washington during the 1950s was characterized by political hysteria and witch hunting. Ernest DeMaio helped create the United Electrical Workers' Union in 1936 but was red-baited many years later for his political affiliations. Here DeMaio and supporters gather at the Chicago Federal Building in 1952 to protest his summons to the House Un-American Activities Committee; as a result, the case was dismissed. (Courtesy of IALC.)

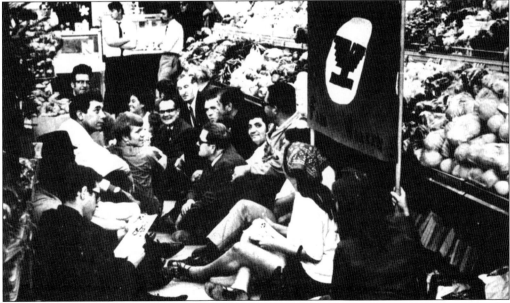

DeMaio was a universal political activist. He was a member of the World Trade Federation at the United Nations and a voice of labor against the Vietnam War. In the center of this photograph, DeMaio organizes a boycott in the fruit and vegetable aisle of Jewel Food Store. This sit-in was to support striking farmworkers in California. (Courtesy of IALC.)

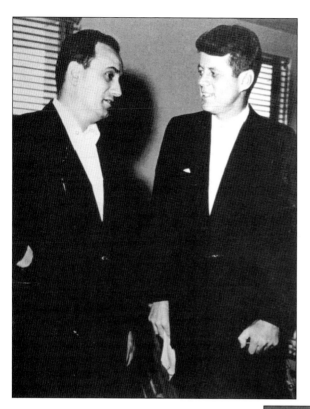

By the 1960s, organized labor found a friend in high places. Here Lou Montenegro, of the International Ladies Garment Workers' Union, speaks with John F. Kennedy. (Courtesy of IALC.)

Jimmy Hoffa was a controversial figure throughout his rise from truck driver to national boss of the International Teamsters' union. In this picture, Hoffa (left) raises hands with Joseph Glimco a leader of the Chicago Taxi Cab Drivers' Union. These two leaders formed an alliance that led to political victory for Hoffa. (Courtesy of Dominic Candeloro.)

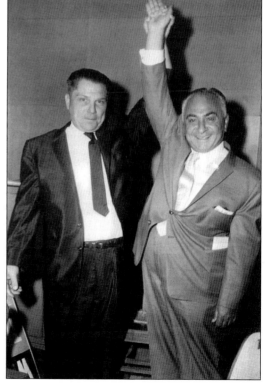

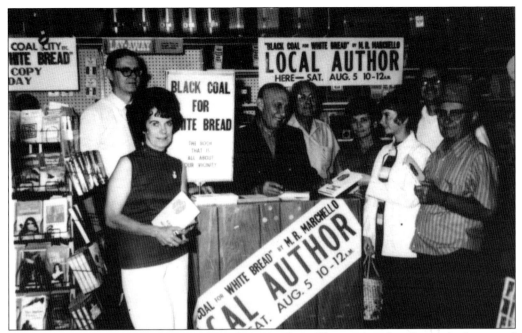

Maurice Marchello lived a rags-to-riches tale in southern Illinois. As a boy, he worked in a coal mine as a slag crusher. By his teens, he worked for the railroad. At the age of 24, Marchello earned a law degree and later became an attorney for the State of Illinois. In this photograph, Marchello autographs his book *Black Coal for White Bread* in 1962. (Courtesy of the IHRC, University of Minnesota, IM000642.)

For many decades, the Amalgamated Clothing Workers' (now a part of UNITE HERE) has been active in labor and politics. Here Joseph Saviano, at the podium, addresses a crowd at the old Amalgamated Clothing Workers' Union Hall. Murray Finley (left of podium) and Attilio DiNello (right) wait for their turns to speak at the union hall. (Courtesy of UNITE HERE.)

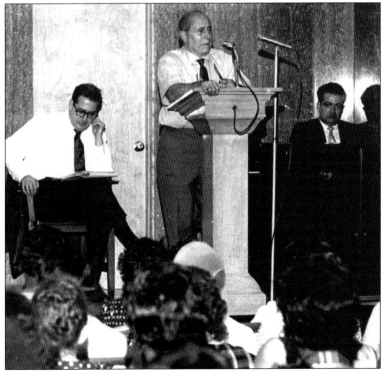

Vito Brando (second from right) was a political organizer for the UAW. Here he campaigns with Minnesota senator Hubert Humphrey (far left) and founder of the UAW Walter Reuther (far right). (Courtesy of IALC.)

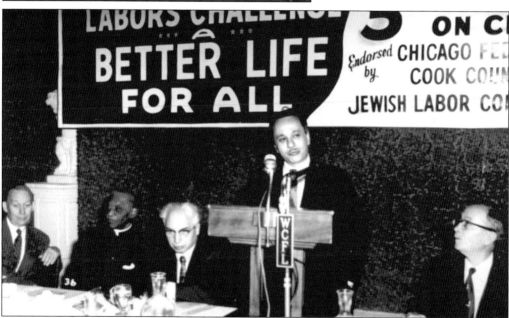

In the 1960s, ethnic labor groups worked in tandem to promote civil rights, universal health care, and consumer protection. At this dinner rally, Paul Iacinno of the Italian American Labor Council builds bridges with the Jewish Labor Council in Chicago. Iacinno was an ideal "bridge builder" because he held past union memberships with the garment workers, musicians, and autoworkers. (Courtesy of IALC.)

Peter Fosco mastered the art of labor and politics for more than 50 years. At 19 years old, he arrived in Chicago from Pizzone, Italy, and worked in the streets as a sewer and tunnel worker. By 1968, he became the head of the Laborers' International Union, an organization of more than 600,000 members in the construction trades. Fosco is pictured here (at left) with Illinois senator Paul Douglas. (Courtesy of the Chicago History Museum, i51571.)

In 1945, the Chicago Park District created a two-acre recreation center to serve parents and youth in a public housing district near Blue Island Avenue and Racine Street. By the year 2000, the city had outgrown the old center and constructed a new one at 1212 South Racine, shown here. (Photograph by Peter N. Pero.)

An old veteran of the Democrat Party and the Chicago City Council was Roman Puchinski (left) shown here with Joseph Ungari (right) of the retail workers' union. (Courtesy of the Ungari family.)

A taste of Chicago? Vincent Tenuto (at microphone) has organized the annual St. Joseph's Feast in Chicago since 1977. To the right of him are a Jewish rabbi, a Protestant minister, Chicago mayor Richard J. Daley, and a Catholic priest. (Courtesy of the Tenuto family.)

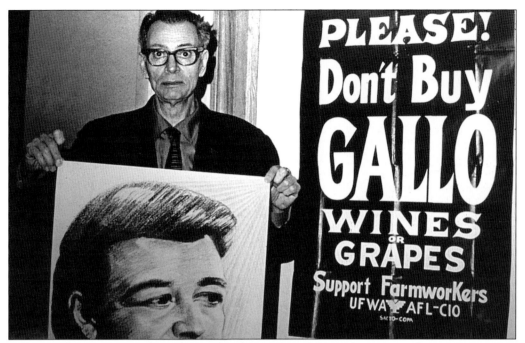

Following his retirement from the steelworkers, Mario Manzardo continued to support union causes and to write labor history. He is shown here in support of the United Farm Workers' grape boycott during the early 1970s. (Courtesy of the Manzardo family.)

Manzardo (top left) was more than 70 years old when this photograph was taken near his home in Hyde Park. He was the oldest member of the farmworkers' support team in Chicago but no less active. (Courtesy of the Manzardo family.)

Former Chicago mayor Harold Washington built political bridges to many ethnic constituents. Here he stands with Egidio Clemente, an elder socialist news editor, during Clemente's lifetime achievement ceremony at the Midland Hotel in 1980. (Courtesy of Dominic Candeloro.)

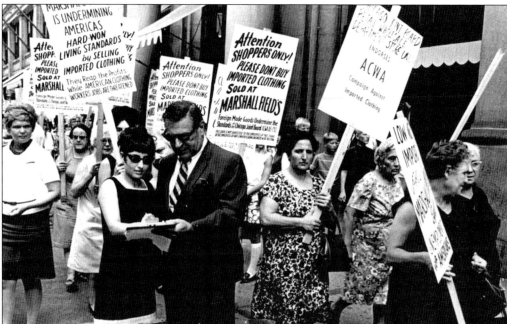

As imported clothing flooded the American market, Chicago workers lost jobs. The Amalgamated Clothing Workers' Union helped to organize this boycott against the Marshall Field Company in 1969. Here marchers walk a picket line at State and Madison Streets in the Loop. Irv Kupcinet (foreground) reports on the event for the local news. (Courtesy of UNITE HERE.)

Frank Annunzio's parents came from Calabria, Italy, and Annunzio's first job as a child was shining shoes near Hull House on Chicago's West Side. Later he became a teacher in the Chicago Public Schools. Annunzio moved into the field of organized labor during the 1940s, when he worked as education director for the USW. By 1964, he was appointed director of the Illinois Department of Labor. (Courtesy of the U.S. Congress.)

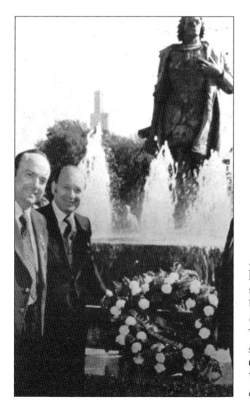

Annunzio was elected to the U.S. Congress from his Chicago district 13 times. He led the campaign to make Columbus Day a national holiday in the United States. Here the congressman appears (at right) with Anthony Judge, a leader of the Teamsters' Union Joint Council. The Columbus statue was erected in 1893, for the World's Columbian Exposition but was later moved to Victor Arrigo Park in Little Italy. (Courtesy of IALC.)

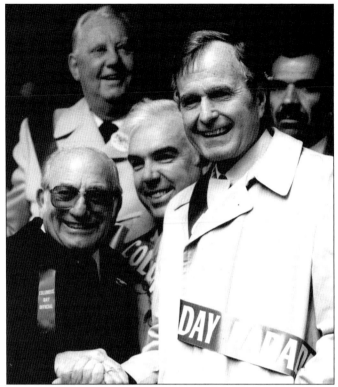

The Columbus Day parade is a flash point for ethnic pride and political positioning. In this photograph, Pres. George H. W. Bush (right) meets with James Coli Jr. of the Teamsters' union (center) and Nello Ferrara (left), the son of the founder of Ferrara Pastries on Taylor Street. (Courtesy of the Ferrara family.)

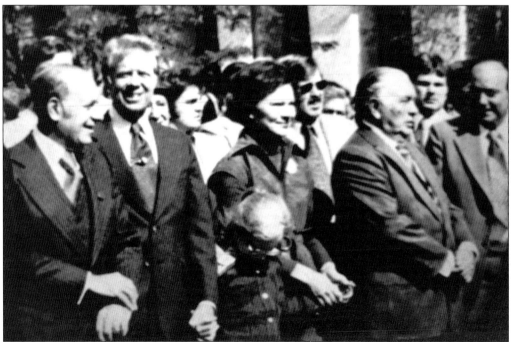

Democrats present a show of solidarity at the annual Columbus Day parade on State Street. From left to right are Congressman Frank Annunzio, Pres. Jimmy Carter (with Roselind and Amy Carter), plus Chicago mayor Richard J. Daley. (Courtesy of IALC.)

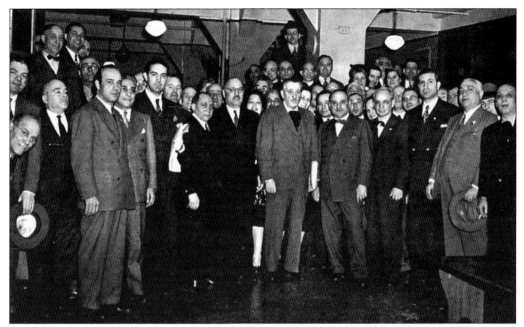

On December 20, 1941, the Italian American Labor Council was formed in New York City. It was formed partly as a response to America's declaration of war against the Axis forces in Europe. Italian labor wanted to show their loyalty and support for the American cause. (Courtesy of La Parola del Popolo.)

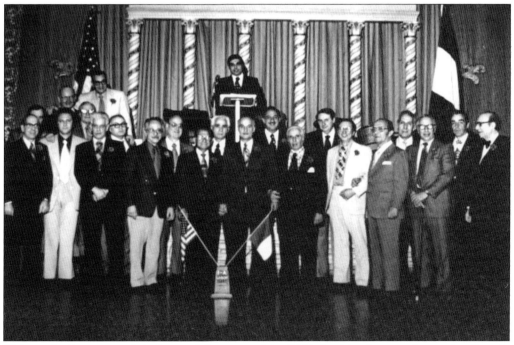

Chicago Italians created their own labor council in 1966. In this photograph, nearly all trade unions with Italian American membership attended this inauguration of the Italian American Labor Council of Greater Chicago (IALC). (Courtesy of IALC.)

The purpose of the IALC is to combat discriminatory labor practices, lobby for progressive legislation, give assistance to new immigrant workers, and sponsor social activities for members. In this photograph, Joseph Falcone of the Hotel Service Workers' Union signs up new IALC members at the annual picnic. (Photograph by Peter N. Pero.)

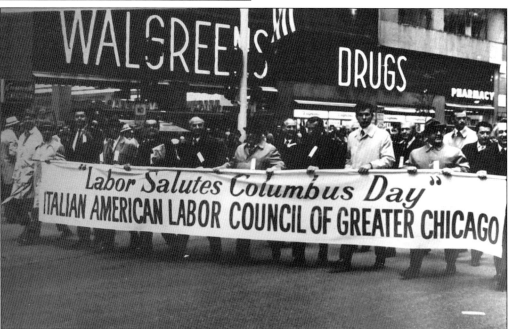

Since 1966, the IALC has marched in the Columbus Day parade on State Street in Chicago. Every year, Italian Americans march in Chicago, in part to honor the spirit and work of their immigrant ancestors. (Courtesy of IALC.)

BIBLIOGRAPHY

Adelman, William J. *Haymarket Revisited*. Terre Haute, IN: Moore Langen Company, 1976.

American Federation of Musicians. *The Eventful Decade*. New York: American Federation of Musicians, 1955.

Cahn, Bill. *Mill Town*. New York: Cameron and Kahn, 1954.

Candeloro, Dominic. *Chicago's Italians: Immigrants, Ethnics, Americans*. Charleston, SC: Arcadia Publishing, 2003.

———. *Italians in Chicago*. Charleston, SC: Arcadia Publishing, 2001.

Costigan, Joseph (treasurer of UNITE HERE, Chicago and Midwest joint board), interview by Peter N. Pero, October 16, 2007.

Giornale di Sicilia. Palermo, Italy: Museo del Mare.

Leiter, Robert D. *The Musicians and Petrillo*. New York: Bookman Associates, 1953.

Linton, Cynthia, ed. *The Ethnic Handbook*. Chicago: Illinois Ethnic Coalition, 1996.

Miller, Eugene, and Gianna Panovsky. "Radical Italian Unionism: Its Development and Decline in Chicago's Mens Garment Industry, 1910–1930." Conference at Illinois Institute of Technology, October 9–10, 1981.

On the Job in Illinois: Then and Now. Chicago: Illinois Labor History Society, 1976.

Orear, Leslie (president emeritus of the Illinois Labor History Society), interview by Peter N. Pero, July 18, 2007.

Pero, Peter N. "A Brief History of Italians in Chicago's Labor Movement." *La Parola del Popolo* 39, (November/December 1978): 120–125.

Romano, Vince (director of the Taylor Street Archive Project), interview by Peter N. Pero, June 14, 2007.

Schnapper, M. B. *American Labor: A Pictorial Social History*. Washington, D.C.: Public Affairs Press, 1975.

Vecoli, Rudolph. "Vecoli on Italian Labor." *La Parola del Popolo* 50, (1976): 55–61.

Across America, People are Discovering Something Wonderful. Their Heritage.

Arcadia Publishing is the leading local history publisher in the United States. With more than 3,000 titles in print and hundreds of new titles released every year, Arcadia has extensive specialized experience chronicling the history of communities and celebrating America's hidden stories, bringing to life the people, places, and events from the past. To discover the history of other communities across the nation, please visit:

www.arcadiapublishing.com

Customized search tools allow you to find regional history books about the town where you grew up, the cities where your friends and family live, the town where your parents met, or even that retirement spot you've been dreaming about.